IMAGES
of America

BOSTON LIGHT

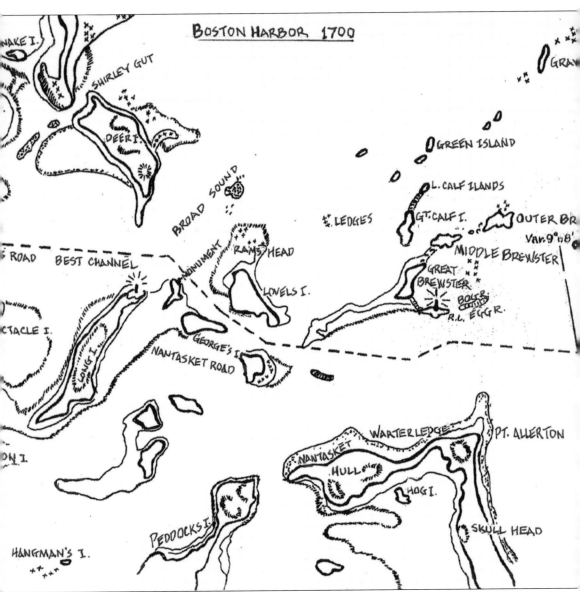

This is a map of the Boston Harbor islands around 1700. Toward the bottom right is the town of Hull with Point Allerton's headland pointing toward the Brewster Islands. Nantasket Roads is the main ship channel passing between the two. The dotted line indicates the route into Boston's seaport. (Courtesy of George Ward.)

ON THE COVER: Boston Light sits on a rocky outcrop at the outer entrance of Boston Harbor. This photograph, dated December 7, 1939, captures a tranquil moment at Little Brewster Island, showing calm seas and quietude. At other times, raging storms can ravage the island. (Courtesy of James Claflin.)

IMAGES
of America

BOSTON LIGHT

Sally R. Snowman and
James G. Thomson

ARCADIA
PUBLISHING

Copyright © 2016 by Sally R. Snowman and James G. Thomson
ISBN 978-1-4671-1708-1

Published by Arcadia Publishing
Charleston, South Carolina

Printed in the United States of America

Library of Congress Control Number: 2016930929

For all general information, please contact Arcadia Publishing:
Telephone 843-853-2070
Fax 843-853-0044
E-mail sales@arcadiapublishing.com
For customer service and orders:
Toll-Free 1-888-313-2665

Visit us on the Internet at www.arcadiapublishing.com

*To the US Coast Guard and US Coast Guard Auxiliary
as stewards of Boston Light.*

CONTENTS

ACKNOWLEDGMENTS

Photographs within this book were provided as a courtesy from a number of individuals and organizations, as well as from the authors' collection. Others were helpful in the search for photographs and illustrations. Heartfelt gratitude is given for the assistance provided by the following, with apologizes to anyone inadvertently omitted: James Claflin, Candace Clifford, Hugh Daugherty, Jeremy D'Entremont, Willie Emerson, Friends of Flying Santa, the Gatcomb family, Historic New England, Hull Lifesaving Museum, Giacinta Bradley Koontz, James Lampke, Pilgrim Congregational Church, Dolly Snow Bicknell, Thomas A. Tag, Brian Tague, Tufts Medical Center, Shea Naval Aviation Museum, Victoria Stevens, Audrey and Richard Tessier, Sydney Underwood, US Coast Guard, US Coast Guard Historian's Office, Lynn Waller, and George Ward. We greatly appreciate the technical support we received from Jennifer Richardson, John Richardson, and Brian Tague; the proofreading of avid supporter Shirley Snowman Richardson; and the infinite encouragement of Beverly Snowman DeMorat and Kelly Richardson Schofield.

INTRODUCTION

Boston Light, established in 1716, is the oldest and last manned US Coast Guard light station in the country, entering into a fourth century as a major aid to navigation guiding mariners into Boston Harbor. Little Brewster Island is the home of the sentinel sitting on the edges of Massachusetts Bay and the harbor. Its history weaves a story of Boston's colonization, politics, development as an international seaport, culture, technology, architecture, and the people who settled in the area. Today, the lighthouse may appear obsolete with the advent of electronic navigational wonders. However, for recreational boaters with few or no reliable devices, the lighthouse remains a welcome sight as it was in bygone days.

Approximately 10,000 years ago, a glacier deposited a thick layer of ice across much of the North American continent, including New England. As the ice receded, it left behind the islands, bays, rivers, and tributaries that formed what are now referred to as the Boston Harbor Islands. Glacial deposits in the outer harbor formed many outcroppings, including the Brewster Islands to the south and the Graves Ledges to the north. They were named in honor of prominent men of the early 17th century who were instrumental in the colonization efforts in the Boston area. Elder William Brewster (1566–1644) was one of the founders of the Plymouth Colony, sailing from Plymouth to explore Boston Harbor. Rear Adm. Thomas Graves (1605–1653) was a prominent seafarer of the Massachusetts Bay Colony, becoming a high ranking officer of the Royal Navy.

Entrepreneurs, explorers, and those seeking a new life sparked interest in coming to the New World. Increased population resulted in the growth of commerce with the need for supplies and household goods. In these early years, local manufacturing was nonexistent, requiring all commodities to be imported from England. Ships from Europe brought settlers and merchandise. On the return trip, ships were loaded with lumber from the New England forests to replenish the dwindling timber resources needed to sustain the Royal Navy's shipbuilding endeavors. The abundance of cod in Massachusetts Bay enabled settlers to supplement the challenges of farming the region's poor soils. Quickly capitalizing on this bounty, they developed the first industry in America, the exporting of salted cod.

Crossing the Atlantic with rudimentary charts and navigational equipment was challenging enough; finding safe passage into Boston Harbor through the deep channel of Nantasket Roads was another challenge. The entrance was a one-mile span between the hill of Allerton Point in the town of Hull and Little Brewster Island. Ships, powered by sail only, required wind to maneuver, entering the harbor when prevailing winds and tides permitted, day or night and often in precarious weather. Frequently, ships would be blown off course or become disoriented in limited visibility, such as fog or blinding snow. Such treacherous conditions led to shipwrecks on the outer ledges of the Brewsters and the Graves, resulting in the costly loss of ships, crews, cargos, and passengers within a few miles of the safe haven of the inner harbor. These costs were deterrents to the colonization efforts.

At the beginning of the 18th century, the merchants and seafarers of Boston and the surrounding communities petitioned for a beacon to be erected to indicate the entrance to Nantasket Roads. On July 23, 1715, the provincial government answered this call by passing legislation to establish a lighthouse. Little Brewster Island, owned by the Town of Hull, was ascertained to be the most desirable location. In August 1715, Hull transferred the property to the Province of Massachusetts.

The lighthouse station completed in 1716 was comprised of a 60-foot tower constructed of granite rubble stone, a wood-framed keeper's house, a barn, and a wharf. The lantern was described as having a semi-opaque glass lens housed in a wooden frame, illuminated with ordinary household candles or possibly oil lamps. It was first lit at sunset on Friday, September 14, 1716, by the newly appointed keeper, Capt. George Worthylake. As a ship's captain, he was permitted to augment his conservative lighthouse salary by piloting ships entering and departing Boston Harbor. The profession of harbor pilot has endured into the 21st century. Additional income was derived from raising sheep on adjacent Great Brewster Island, which was accessible by walking across an exposed mussel bar at low tide. In the winter of 1717, some of the sheep strayed onto Great Brewster Spit. Detained with his keeper duties, Worthylake was unable to attend to the sheep. When storm-driven waves covered the bar, the sheep were swept into the sea and drowned. He petitioned to be compensated for the loss of the sheep, but the request was denied. A year later, on November 3, 1718, a tragedy occurred when Worthylake and four others drowned. They were returning to the island from a trip into Boston when their rowboat unexpectedly capsized as they were approaching the island.

Capt. Robert Saunders, a sloop captain, temporarily manned the light until the slated appointed keeper, Capt. John Hayes, became available. Saunders was on duty for only a few days when he was also reported to have drowned. By November 18, 1718, Hayes was on duty. During this time, it was customary for ships to fire black powder from a large gun or cannon when navigating through fog when they suspected other vessels to be nearby. After it was fired, they would wait for a reply. The loudness of the sound would indicate how close vessels were to each other, and they could take action to avoid collision. Hayes had no means to signal to the vessels warning them of their proximity to the ledges. He requested a "great gun" from the provincial government to answer ships in the fog. It was approved, and a cannon was sent to the island in 1719; thus, Boston Light became a fog signal station as well as a light station. Today, the cannon is the oldest Coast Guard artifact in the country and is on display at Boston Light. In 1733, keeper Hayes resigned after 15 years due to concerns of his age preventing him from properly carrying out his duties.

Capt. Robert Ball, appointed as the fourth keeper in 1733, remained for 41 years. Of the 70 keepers of Boston Light, Ball has held the position the longest. During his tenure, the tower was in constant need of repair, sometimes due to fire, other times due to poor construction and limited funds for repairs. Upon Ball's retirement in 1774, William Minns was appointed, and was listed as the keeper until June 1776. There were skirmishes between the Revolutionaries and the British intermittently from June 1774 until the British evacuated the island on June 13, 1776, blowing up the tower upon their departure. Little was recorded of Minns's presence on the island during this period or what transpired at Little Brewster from the time the king's troops withdrew from Boston until the Treaty of Paris was signed on September 3, 1783. Mention is made of a fire pole having been erected for hoisting an iron pot filled with burning wood or coal to guide friendly ships into the harbor at night. Another mention was made of a temporary unlighted tower placed on the island as a day mark.

At the conclusion of the Revolutionary War, the tower was promptly reconstructed by the Commonwealth of Massachusetts, with the light relit on December 5, 1783, by Capt. Thomas Knox, the sixth keeper of Boston Light. The newly established US government received custody of Little Brewster Island on June 10, 1790.

Over the next 232 years, the tower was refurbished numerous times. Technological improvements through the centuries brought various modifications and changes to the lighting apparatuses and fog signal devices. The 14th keeper, Moses Barrett, witnessed significant changes to the station during his tenure (1856–1862). In 1856, the keeper's house was a two-story whitewashed wooden

structure with a parlor, sitting room, kitchen, and six bedrooms. The lighthouse was 66 feet, 11 inches tall, with the lantern room containing an illumination apparatus of 16 rotating Argand lamps. In 1859, the house was replaced by a two-story duplex dwelling for the keeper, an assistant keeper, and their families. A brick oil room was added as an entry area leading into the tower. An enclosed, covered walkway extended from the oil room to the duplex house. The tower was raised to 89 feet to accommodate the installation of an 11-foot, second-order Fresnel lens with its clockwork-driven rotation machinery. A brick lining was placed in the tower as additional support for the weight of the 4,000-pound lens mechanism. On December 20, 1859, the Fresnel lens cast its powerful beams across Massachusetts Bay for the first time.

Management of the Lighthouse Service changed in 1939 when it was absorbed into the US Coast Guard. Maurice Babcock was to be the last civilian Lighthouse Service keeper at Boston Light, serving from 1927 to 1941. First assistant keeper Ralph Norwood was offered a promotion to principal keeper and given a choice to remain a civilian employee or join the Coast Guard as a first class petty officer. Upon his appointment as the keeper in 1941, Norwood opted to enlist. The significance of this administrative change became apparent in 1958, when preparations were made for Boston Light to transition from a family station to a "stag"—all male—station.

By 1960, wives and children had been relocated to the mainland. History repeated itself in 2003, when the activity duty billet reverted to a Coast Guard civilian position, precipitated by the state of the nation in the wake of the September 11, 2001, terrorist attacks. This shifted the manning of Light Station Boston back to a civilian keeper and a cadre of Coast Guard Auxiliary volunteers, with the Coast Guard reassigning its active-duty personnel to other missions. Seventy documented principal keepers have been appointed since the station was established in 1716. Although an accurate number of assistant keepers from the Lighthouse Service and the Coast Guard are uncertain, 127 have been identified.

Boston Light, although situated on an island, has not been isolated from the influences of the mainland. Congressional laws govern the management of Little Brewster Island and Light Station Boston to ensure it is preserved for posterity. Driven by fiscal constraints, the station was slated to become automated and unmanned in 1989. Opposition to this proposal resulted in legislation requiring Boston Light to remain manned, have a Coast Guard presence, promote public access, and develop and maintain a strategic plan to ensure compliance with the new laws. Further legislation in 1996 established the Boston Harbor Islands National and State Park. Little Brewster Island is one of the 34 islands and peninsulas comprising the park. It is unique because the National Park Service only owns 0.06 acres of the property within the park. Management of the park is a partnership amongst the property owners and a legislated nonprofit fundraising agency, Boston Harbor Now. The Coast Guard, being one of the property owners, is a mandated partner. The partnership was instrumental in establishing public access to Little Brewster as stipulated in the 1989 legislation. A historical interpretive and educational program was developed in 2000 to provide informative and enjoyable experiences for the visitors who accompanied park service–sponsored tours. To provide safe access to the island, the National Park Service financed a $1.8-million docking facility constructed in 2009–2010. Boston Harbor Now and Boston Harbor Islands National and State Park continue to manage the administrative logistics and provide program support for a 16-week Boston Light summer tour season.

The Coast Guard remains committed to maintaining the infrastructure of the island. Major repairs, restoration, and upgrading projects costing in excess of $2 million took place between 2013 and 2015. The exterior of the tower was repointed, an unstable portion of the tower reconstructed, and a new protective stucco coating applied. The exterior copper roofing of the lantern room and the interior 1844 iron doors and 76-step spiral staircase were refurbished. The roof shingles of the boathouse (1899), keeper's house (1884), cistern building also referred to as the rain shed (1884), fog signal building (1876), and museum room (1859) were replaced with yellow Alaskan cedar shingles. The slate roof of the oil house (1889) was repaired and rotting wood trim replaced, exteriors of the buildings were painted, and the windows were replaced in the keeper's house. The old sewage treatment plant was removed, and a new one was installed. The 20-year-old

4,000-gallon underground diesel fuel storage tank was decommissioned. Erosion protection efforts of the shoreline have been an ongoing maintenance project for the past 70 years due to continual cycles of storm surges that assault the island all too frequently. These projects required large construction vehicles to be brought to the island, delivered by tugboats pushing transport barges onto the beach for the unloading and removal of supplies and equipment. A temporary road needed to be cleared along the southeast portion of the beach to accommodate forklifts and front-end loaders to move the construction materials.

The fourth century of Light Station Boston is here, and its history continues to be researched, with more stories unfolding. Future generations will also have the opportunity to experience the light and acquire an appreciation of its importance as a major aid to navigation; enjoy it as a rich historic, cultural, technological, and aesthetic resource; and treasure it as a national historic landmark.

One

THE FIRST 200 YEARS

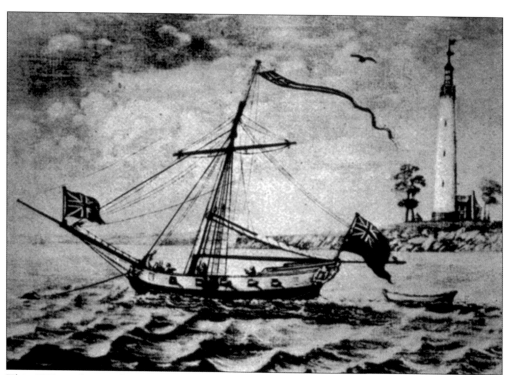

This 1729 rendition of Boston Light is a mezzotint designed, engraved, and painted by William Burgis and titled *Dedicated to the Merchants of Boston*. It shows the British customs harbor pilot boat and lighthouse tender at anchor in the foreground. Boston Light was the first lighthouse established in Colonial America. (Courtesy of the National Archives.)

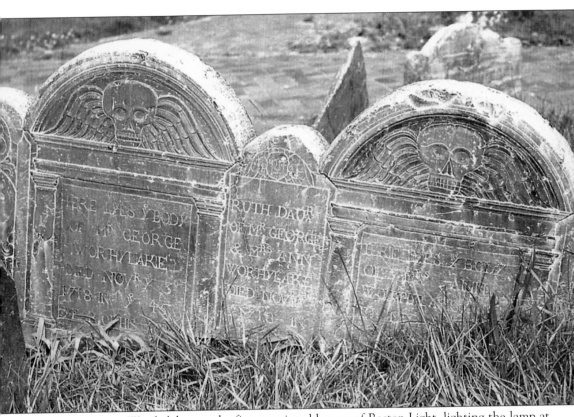

Capt. George Worthylake was the first appointed keeper of Boston Light, lighting the lamp at sunset on Friday, September 14, 1716. As a ship's captain, Worthylake augmented his lighthouse salary by piloting ships that entered and departed the harbor. His tenure ended abruptly when he and four others accidently drowned on November 3, 1718, while returning from a trip to Boston. Those lost were Worthylake; his wife, Ann; their daughter Ruth; their slave, Shadwell; and their friend John Edge. Within close proximity of the island, they had transferred from a sailboat into a smaller boat to row ashore. During the transit, the boat unexpectedly overturned. Witnesses to the tragedy were daughter Ann Worthylake and her friend Mary Thompson. The victims' bodies were recovered from the water and taken to Boston. The three Worthylakes were buried together in one grave at Copps Hill Burying Ground in Boston's North End, marked with a triple headstone. From left to right are George Worthylake, daughter Ruth Worthylake, and wife Ann Worthylake. The temporary keeper, Robert Saunders, also drowned within days of reporting to duty. (Courtesy of Jeremy D'Entremont.)

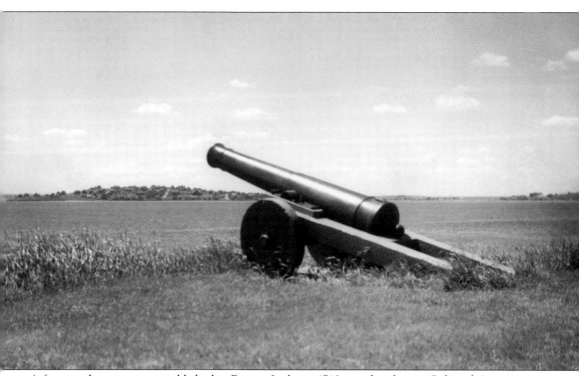

A fog signal station was established at Boston Light in 1719, another first in Colonial America. To avoid a collision in times of limited visibility, such as fog or blinding snow, it was customary for ships to signal others that might be in the vicinity. The signal was a loud booming sound produced by igniting gunpowder in a large gun or cannon. Ships hearing the sound would signal in return, providing the opportunity for the ships to alter course or reduce speed to avoid collision. To prevent ships from wrecking on the Brewsters, keeper John Hayes requested a "great gun" from the colonial government to "answer ships in the fog." A cannon was delivered that was no longer serviceable as a weapon but still useful as fog signal device. Today, this cannon is on display in the museum at the base of the tower. (Courtesy of the Gatcomb family.)

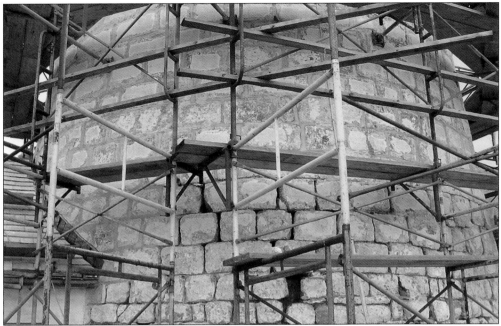

The original granite rubble stone tower was built in 1716. It was destroyed by the British in 1776 upon their evacuation from Boston by detonating a keg of powder at the base of the tower. The lighthouse was rebuilt in 1783 at the conclusion of the Revolutionary War. A Coast Guard–funded restoration project in 2014 revealed evidence of the first few feet of the tower being the original foundation. Above, the lowest portion of the structure has smaller, irregularly cut stones, compared to the 1783 reconstruction with larger, more uniformly cut stone. Below, a lower section of exterior stones was temporarily removed to make structural repairs. Notice that the original interior layer has very small, irregularly shaped stones mixed with mortar. (Both, authors' collection.)

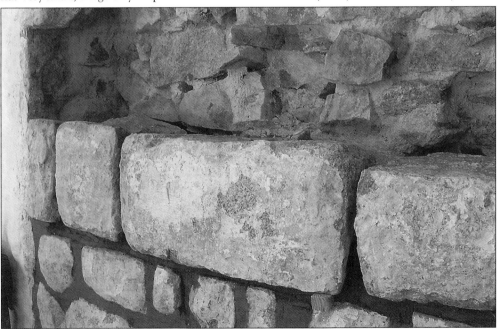

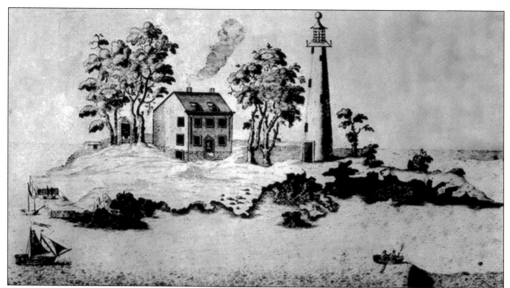

North Prospect of the Lighthouse was published in the maritime reference guide *New England Coast Pilot* (1733–1734). Capt. Cyprian Southack accurately depicted Little Brewster Island as a small rocky outcrop; from left to right are the dock, the keeper's house with its accompanying outhouse, and the 1716 lighthouse. Today, the island is barren of any trees. (Courtesy of the National Archives.)

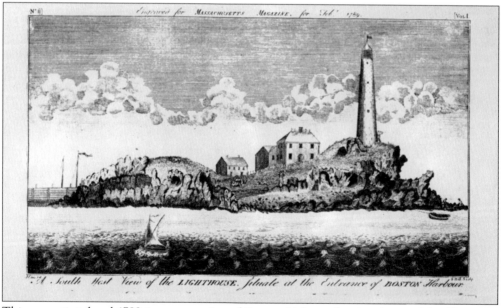

This mezzotint dated 1789 is an engraving of Boston Light at the time keeper John Knox was residing on the island with his family (1783–1811). The top reads: "Engraved for Massachusetts Magazine, Feb 1789." At bottom, it reads: "South west view of the lighthouse situate at the entrance of Boston Harbour." The state of Massachusetts ceded ownership of the lighthouse to the newly established United States government in 1790. (Courtesy of James Claflin.)

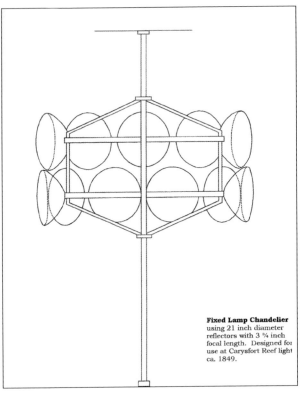

Fixed Lamp Chandelier using 21 inch diameter reflectors with 3 ¾ inch focal length. Designed for use at Carysfort Reef light ca. 1849.

The graphic at left illustrates a type of rotating mechanism at Boston Light around 1811. It was comprised of multiple lamps and reflectors within a chandelier, changing its characteristic from a fixed to a flashing light. This made for a much improved navigational system, as it was easier to differentiate amongst the many lighthouses that had begun to light up the Massachusetts coastline. These improvements were followed by technological advances in the mid-to-late 1850s, with apparatus that burned efficiently with less fuel oil while producing a much brighter light. Boston Light had sixteen 21-inch Argand lamps around 1855. The graphic below depicts a Winslow Lewis–Benjamin Hemmenway style Argand fountain lamp with a 21-inch reflector mounted on the chandelier. The mechanism rotated via clockwork. (Both, courtesy of Thomas A. Tag.)

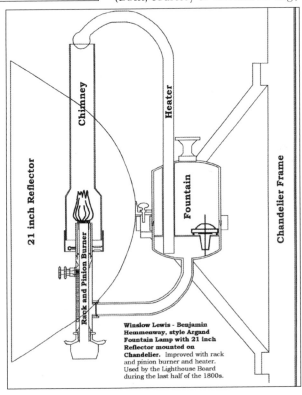

Winslow Lewis - Benjamin Hemmenway, style Argand Fountain Lamp with 21 inch Reflector mounted on Chandelier. Improved with rack and pinion burner and heater. Used by the Lighthouse Board during the last half of the 1800s.

Long Island Head Light, the second lighthouse to be established in Boston Harbor, had four towers constructed within an 82-year period. First was a 20-foot stone tower established on October 9, 1819. In 1844, it was replaced with a 34-foot cast iron tower, the first of its kind in the country. The South Boston Iron Company cast the iron for this lighthouse as well as the double iron doors that continue to be in service at the base of the Boston Light tower. A fourth-order Fresnel lens was installed in 1857. A new cast iron tower was constructed in 1881. Due to the increased fortification of the island's military compound in close proximity, the lighthouse was relocated in 1901 and a new 52-foot brick tower constructed. In 1929, the light was automated; in 1982, it was decommissioned; in 1985, it was refurbished and recommissioned; and in 1998, major renovations were made. On June 25, 2011, ownership of the lighthouse and 0.06 acres was transferred to the National Park Service. The Coast Guard continues to maintain the light. (Courtesy of James Claflin.)

Above is a c. 1830 drawing of Boston Light entitled *Representation of the Outer Light-house, Boston Harbor*. It is a unique view from the northeast rocky outcropping of Little Brewster Island, with someone fishing on the rocks at lower left. The fog signal cannon is visible on the grounds to the left of the tower. A two-story single-family dwelling for keeper Jonathan Bruce (1811–1833) is to the right. The photograph below shows the southwest portion of the island at low tide, showing its tidal pools. Keepers and their families took advantage of the abundance of seafood available on the island. Lobsters were obtained by plucking them out of the tidal pools. The plentiful mussels and crabs could easily fill a bucket. (Above, courtesy of the US Coast Guard Historian's Office; below, courtesy of Brian Tague.)

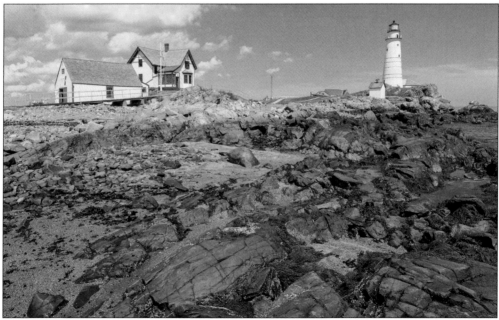

A tower restoration project occurred in 1844. It included the installation of a cast iron spiral staircase of 76 steps to a landing with a ladder leading to the lantern room. Each step was attached to the center post. A wrought iron handrail was on the outside of the stairs. Replacement iron window frames were also provided for each of the tower's five windows. The photograph at right shows the central post, a few steps, the handrail, and one of the window frames. Below is the top tower window, located by the platform, and the ladder leading to what would have been the lantern room in 1844. The interior brickwork was installed in 1857–1859 as additional support for the installation of the 4,000-pound classical second-order Fresnel lens in 1859. (Both, courtesy of Brian Tague.)

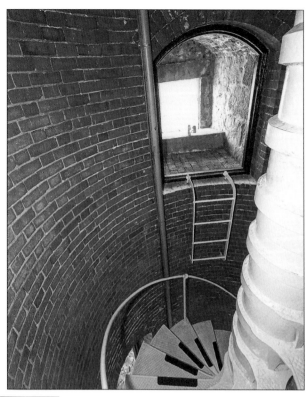

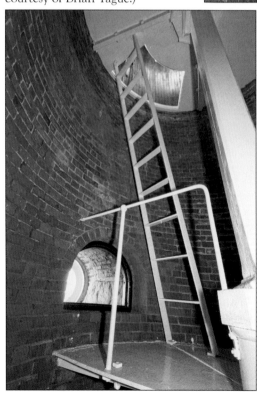

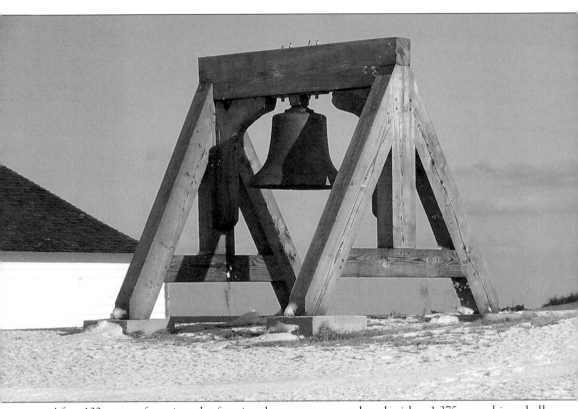

After 132 years of service, the fog signal cannon was replaced with a 1,375-pound iron bell (1851–1872). It was comprised of a clockwork mechanism that was wound every six hours and a clapper timed to strike at intervals of 47 seconds. An upgrade was made to the mechanism in 1869, when a Steven's striking apparatus was installed. This photograph, taken at Boston Light, shows a representation of a period wooden fog signal stand with a 1,010-pound bell dated 1891, not the original. In 1851, Congress addressed concerns over the deterioration of the Lighthouse Establishment and its failing infrastructure. An investigation was made to determine the condition of lighthouse structures, equipment, and management. The report submitted recommended revamping the entire system. As a result, the Lighthouse Board was established on October 9, 1852, providing new leadership for improved quality of construction, maintenance, and personnel, as well as the adoption of the Fresnel lens. (Authors' collection.)

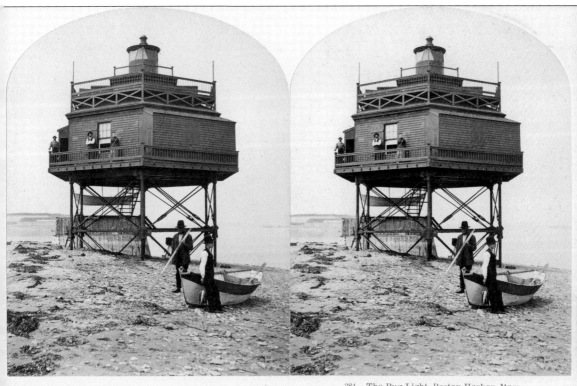

384. The Bug Light, Boston Harbor, Mass.

The Narrows "Bug Light" (1856–1929) marked the entrance to the Narrows Channel leading into the inner harbor. The nickname Bug Light was derived from it looking like a bug with its six-sided wooden lighthouse sitting on seven cast iron screw-pile legs. It was the only one of its type built in New England due to concerns that winter ice conditions would endanger the pilings. To protect them, a structure was added of stone encased with oak planking reinforced with iron bands, visible in the background of this c. 1870 photograph. There were a variety of structures intended to prevent ice throughout the station's 73 years of service. The lantern room housed a sixth-order Fresnel lens with a fixed red light. The sound signal device was a bell with a wind-up clockwork mechanism. On June 7, 1929, keeper Thomas Small was removing paint with a blowtorch when the building accidently caught fire. Small was able to evacuate the island via the station's rowboat before the structure collapsed. (Photograph by Benjamin W. Kilburn, courtesy of James Claflin.)

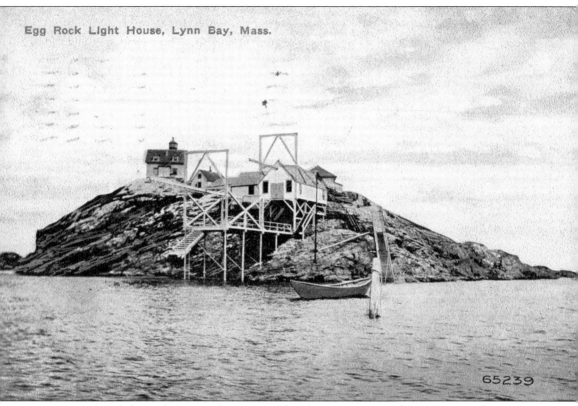

Egg Rock Light House, Lynn Bay, Mass.

65239

Egg Rock Lighthouse (1856–1922) was situated at the entrance to Nahant Bay, six miles northwest of Boston Light. The island, a three-acre egg-shaped rock, was especially hazardous for the fishing fleets of the coastal communities, with many vessels having wrecked upon it. Established in 1856, the lantern room with a fifth-order Fresnel lens was the center point of the keeper's stone house. It is believed that the structure was built from stone quarried from the island. The optic was initially a fixed white light but was changed to a fixed red light in 1857. The structure was destroyed by fire in 1897 and replaced with a square brick tower and a wood-framed house; an oil house was added in 1904. This c. 1912 photograph illustrates the precariousness of getting onto the island. The station was decommissioned in 1922. In 1927, the state took ownership of the island, and it is now a bird sanctuary. (Courtesy of James Claflin.)

Improvements in illumination and fog signal devices resulted in the need for additional personnel trained in operating and maintaining the equipment. The duplex dwelling depicted in this c. 1875 photograph was built in 1859 to accommodate keeper Moses Barrett, an assistant keeper, and their families. In the foreground, a man and a child are posed on a rock. Laid on the ground to the left are linens being dried and bleached by the sun. The wooden buildings have weathered siding, except for the small white well-house that sits in the near center of the photograph adjacent to a garden. The granite stone tower is whitewashed. Water was a scarce commodity; a cistern was reserved for the steam-fired fog signal, not for personal use such as laundry, so well water was needed. On display to the right in the background is the 1719 fog signal cannon that was retired in 1851. (Courtesy of Jane Holbrook Jewell.)

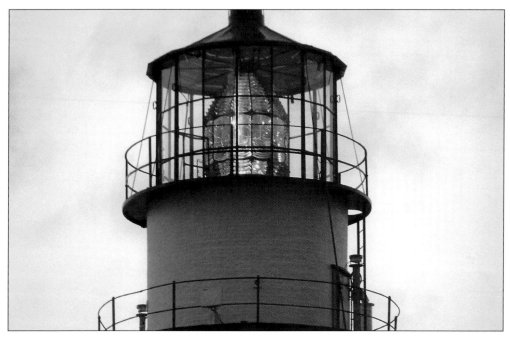

A major upgrade to the station occurred in 1857–1859 with extensive renovations to the tower. Its height was increased from 75 feet to 89 feet to house a classical second-order Fresnel lens made of glass and brass weighing 4,000 pounds. It measured 11 feet tall and 15 feet in circumference and was comprised of 336 prisms with 12 equally spaced bull's-eyes. The old lantern room was modified to become the watch room, enclosed with a brick exterior and interior paneling. An exterior deck provides the means for keeping the lantern room windows clean and free of ice. On December 20, 1859, the lamp was lit for the first time. (Both, courtesy of Brian Tague.)

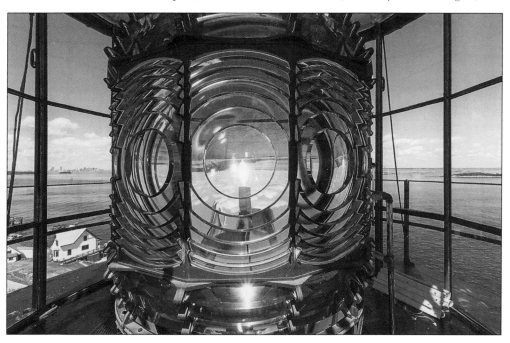

This 1859 Fresnel lens with its reflecting and refracting prisms and magnifying bull's-eyes was manufactured in France by Lepaute. Its first illumination was an oil lamp. Today, electricity is provided by an underwater power line from the mainland. A 1,000-watt lamp is magnified to two million candle power, visible for 27 miles on a clear night. (Courtesy of Brian Tague.)

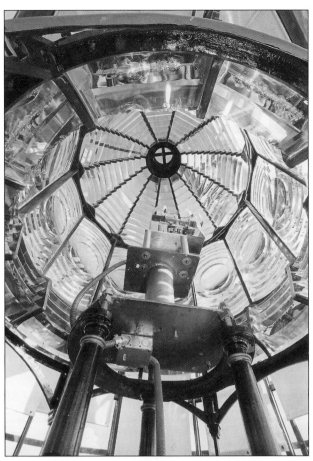

The gear room houses the mechanism that rotates the lens around the stationary illumination. In 1859, this was via windup clockwork. Today, a half-horsepower motor rotates the lens. Eight brass chariot (truck) wheels are the sacrificial metal designed to take the wear and tear, as they are easier to remove and less expensive than replacing the pedestal and base of the lens assembly. (Authors' collection.)

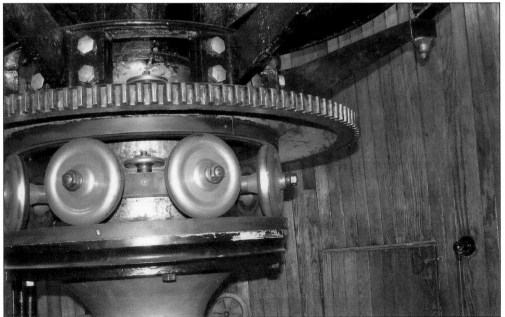

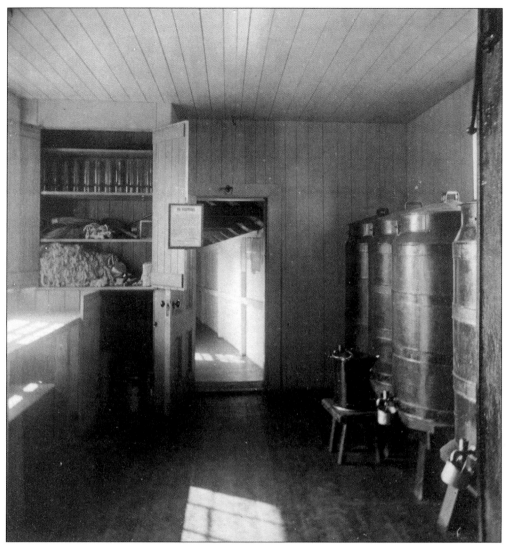

This is a rare c. 1875 photograph taken of the interior of the oil room, a storage area between the connecting, covered walkway from the duplex house to the lighthouse. The cabinet on the left stored glass lanterns and wicking for the lamp. On the right, four metal containers were used for storing the fuel, most likely lard oil. By 1860, the cost of whale oil had become prohibitive, and lard oil, a derivative of pig fat, became the fuel of choice. In 1875, the Lighthouse Establishment consumed about 100,000 gallons of oil for approximately $160,000 (nearly $3.5 million today), thus the locks on the containers. Today, this space is a small museum displaying lighthouse and other aid to navigation artifacts, with no evidence of it having been an oil room. The wall with the door to the walkway now has a floor-to-ceiling display case. (Courtesy of Jane Holbrook Jewell.)

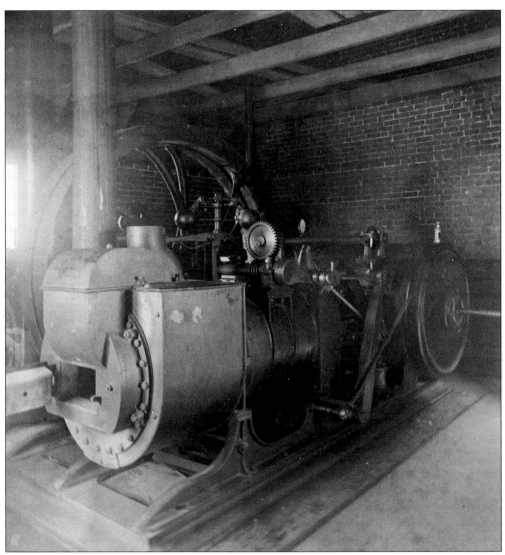

As a fog signal station, Little Brewster Island produced very loud, intermittent sounds during times of limited visibility, when the light could not be seen. This c. 1875 photograph shows one of two coal-powered machines installed in 1872 to generate compressed air for a Daball fog-trumpet. The duplicate engines were to ensure the fog signal could keep sounding for many consecutive days or weeks. Alternating the two engines allowed for one to be maintained while the other was in operation. The deep, throaty sound of the signal was made when compressed air vibrated its 10-inch reed, similar to how a saxophone or clarinet produces sound. Mariners were able to differentiate the fog signal stations in the harbor by each one's unique sound and duration. Bells, sirens, and trumpets were also used as fog signal devices in the 1870s. (Courtesy of Jane Holbrook Jewell.)

The Holbrook family summered on Middle Brewster Island, close to Little Brewster. They would frequently row or sail to Boston Light for a visit. This c. 1875 photograph of the lighthouse was taken from Middle Brewster. The town of Hull is visible in the background. (Courtesy of Jane Holbrook Jewell.)

This is a c. 1875 photograph entitled *Light Keeper's Daughter—Boston Light*. It provides a glimpse of the garments worn by little girls of that era. She is wearing a fashionable plaid dress, striped stockings, and a ribbon in her hair, and sits in a formal pose in a child-sized wooden chair, hands and ankles crossed. (Courtesy of Jane Holbrook Jewell.)

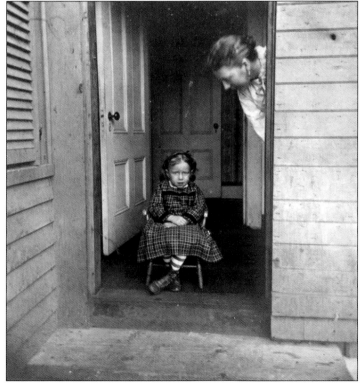

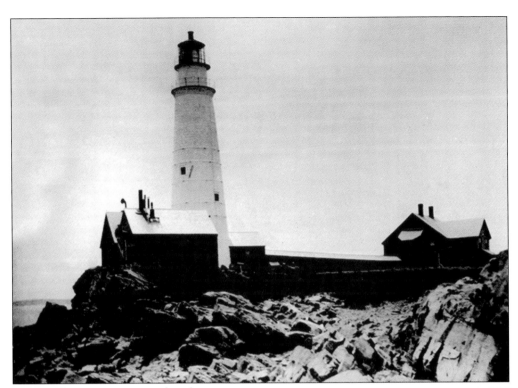

Fog signal apparatus were replaced frequently as technology rapidly developed. This resulted in an array of fog signal buildings being erected, altered, and removed in relatively short periods of time. In 1871, two wooden structures were constructed side-by-side next to the lighthouse tower, as seen above. A third, temporary wooden structure was built about 1874, as shown at right. In 1876, the first two were replaced with a brick structure and the temporary fog signal building dismantled. The 1876 brick structure remains in service today with structural changes that were made in 1886. Both photographs show the covered walkway connecting the oil room and the dwelling. Also visible are the six iron support bands that were placed around the tower in 1809. (Above, courtesy of the National Archives; right, courtesy of the US Coast Guard Historian's Office.)

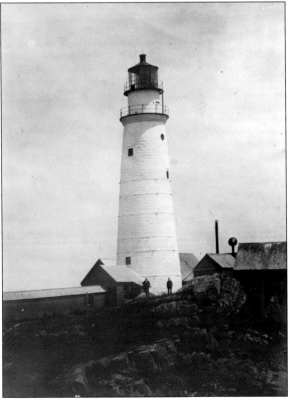

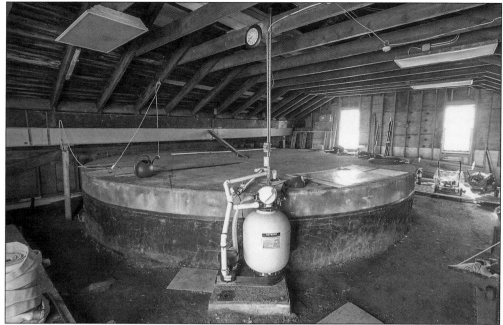

Pictured above is the 21,800-gallon cement cistern that was constructed in 1884 to collect rain water runoff from the 38-foot-by-38-foot roof that it sat under. Its purpose was to collect and stow an adequate amount of fresh water for the steam-powered fog signal apparatus. Unfortunately, the size of the roof was insufficient, filling only a fraction of the cistern's capacity. Well installation efforts were unsuccessful due to the infiltration of saltwater into the island's water table. The high salinity levels would have ruined the machinery. In 1888, the rain shed was enlarged to 77 feet by 85 feet to collect sufficient rainwater to fill the cistern to capacity. Both the 1884 cement cistern and the 1888 rain shed (cistern building), seen below, remain in service today. (Both, courtesy of Brian Tague.)

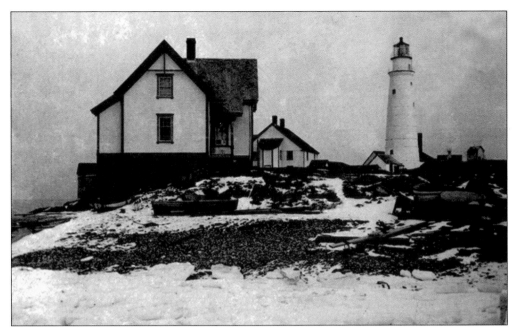

Technological demands of the light and fog signal stations resulted in the need for more housing. The principal keeper's house was constructed in 1884 for the keeper's family. The duplex house was allocated for two assistant keepers and their families. Notice the debris washed above the high-tide line and snow in the foreground, suggesting a stormy winter with high tides around 1890. (Courtesy of the National Archives.)

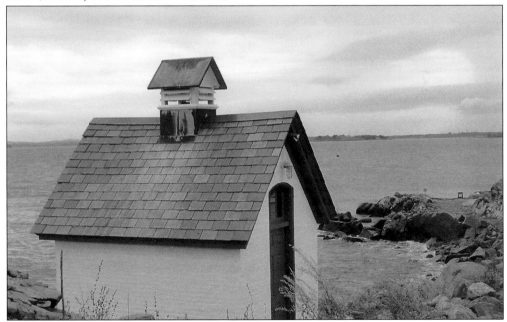

A brick oil house, nine feet by ten feet with a slate roof, was constructed in 1889 for storage of hazardous materials. Its was situated on the south side of the island on a rocky outcrop, as far away as possible from the wooden structures. Today, the building continues to store hazardous materials. (Authors' collection.)

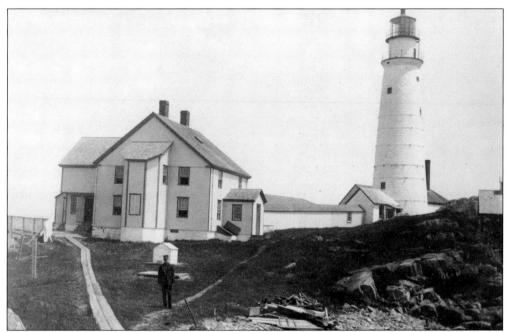

Around 1890, the wooden structures were whitewashed. In the foreground is an assistant keeper in uniform. On the ground behind him is a well house, with remnants of another having been covered. A wooden walkway on the left leads to the back door of the house; a beaten footpath leads toward the tower. (Courtesy of the US Coast Guard Historian's Office.)

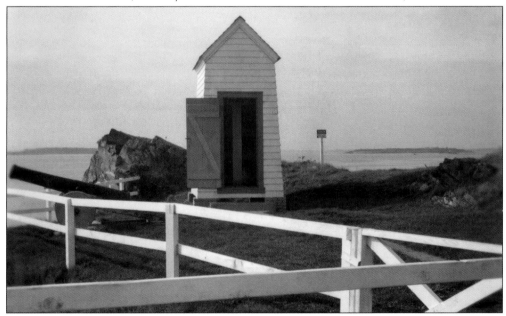

The Boston Auxiliary Light was a third aid to navigation at Little Brewster that was in operation from 1890 to 1960. This small white structure housing a fixed light faced toward Hull Gut, a narrow inlet between Peddock's Island and the tip of the town of Hull's peninsula. It indicated to mariners a safe passageway into the deep channel of the outer harbor. (Courtesy of the US Coast Guard.)

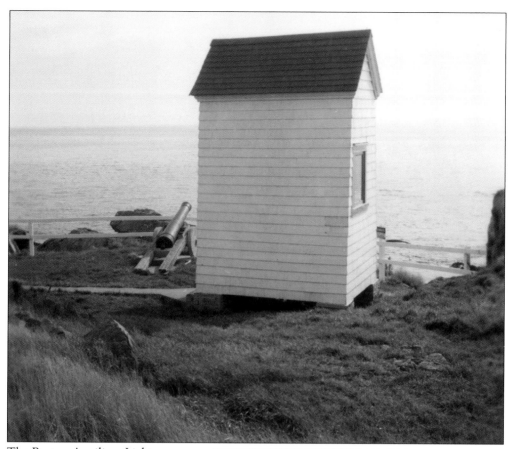

The Boston Auxiliary Light was positioned on a high outcropping on the southeast corner of the island. It guided vessels headed outbound from Hull Gut to steer clear of the hazards of Toddy Rocks and Hunts Ledge. Visible above is the retired 1719 fog signal cannon on display to the left of the structure. In the background is Nantasket Roads, a deep-water channel leading from the outer harbor to the inner harbor. The photograph at right shows the window that displayed the auxiliary light and its magnifying lenses. During World War II, the Fresnel lens in the tower was extinguished as a security measure to deny enemy ships safe passage. However, the Boston Auxiliary Light remained in service for mariners departing the harbor. (Courtesy of the US Coast Guard.)

The Boston Auxiliary Light was illuminated by a small kerosene table lamp, as seen at left. Below are the magnifying lenses, comprised of three sections. One was a clear glass magnifier providing 2,000 candlepower. The other two were red vertical lenses affixed on either side of the clear glass, each providing 600 candlepower. When transiting from Hull Gut toward the deep channel of Nantasket Roads, mariners were to steer a course toward the white light. The vessel's heading would be adjusted to avoid either of the red sectors, adhering to the sailor's lament, "In the white, you're right; in the red, you're dead." The auxiliary light was replaced by a Coast Guard can buoy in the vicinity of Toddy Rocks in 1960. (Both, authors' collection.)

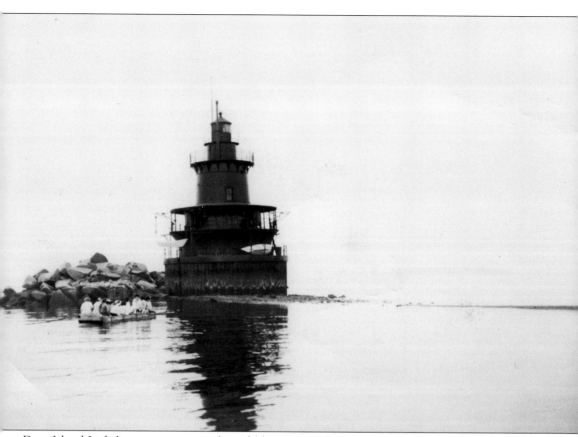

Deer Island Lighthouse, a structure shaped like a spark plug, was first lit on January 26, 1890, marking the north side of the channel of President's Roads. Sitting on an exposed rock, it was a cast iron cylindrical caisson painted brown. It had a circular staircase from the cellar to the watch room. A fifth-order Fresnel lens was housed in the lantern room, displaying a fixed white light with a flashing red light. A fog signal bell was mounted to the exterior of the tower. Both were operated by windup clockwork mechanisms. The light station remained manned until February 19, 1972, when an evacuation occurred at the peak of a nor'easter. High seas had broken through a window, flooding the lighthouse and jeopardizing the stability of the structure. The Coast Guard cutter *Pendant* made a heroic rescue of the keeper and assistant keeper. With repairs being too costly, the lighthouse was unmanned and automated in 1972. Replacement structures were built in 1982 and 2015. (Courtesy of the Hull Lifesaving Museum, Edward Snow Collection.)

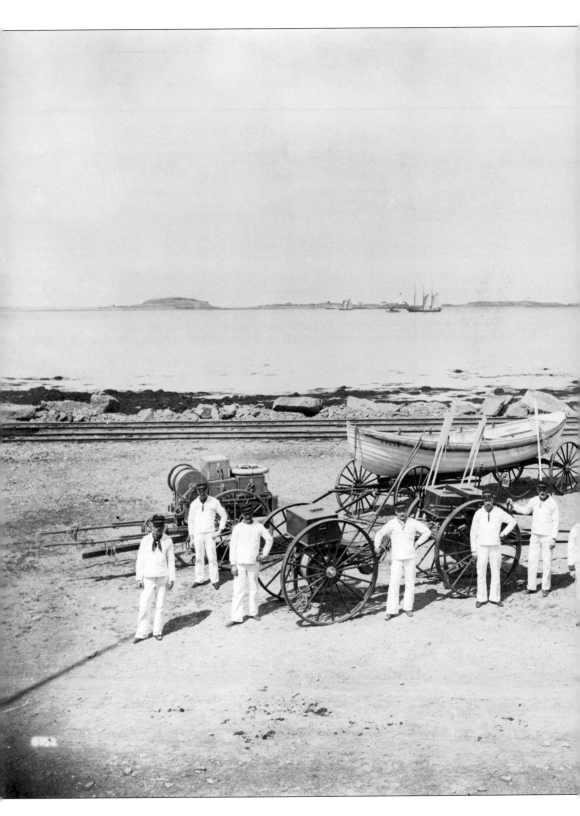

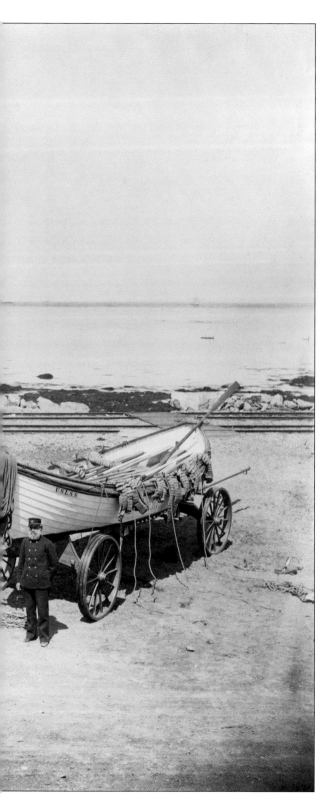

Many heroic missions were conducted by the lifesaving station, launching boats into heavy surf from Stony Beach in Hull. Keeper Joshua James is known to have rescued over 600 people. Shipwrecks occurred along the shoreline as well as upon the Brewsters. Prior to electronic devices, Boston Light as a Lighthouse Service Station communicated wrecks on the ledges to the Point Allerton Lifesaving Station via flag signals. Both services were absorbed into the US Coast Guard, which continues the lifesaving mission and maintains over 50,000 aids to navigation. Boston Light remains the last manned US Coast Guard light station in the country. This photograph, taken by Baldwin Coolidge and dated April 26, 1893, depicts keeper Joshua James, his crew, surfboats, and equipment on Stony Beach with Boston Light and the Brewster Islands in the background. (Courtesy of Historic New England.)

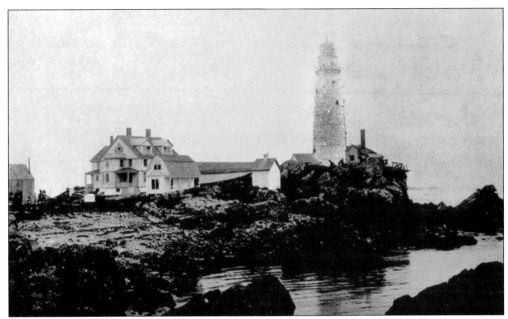

Students from the Massachusetts Institute of Technology (MIT) conducted experiments with a variety of fog signal devices during the months of April to July from 1893 to 1895. There were as many as 30 students living in temporary quarters along with the three keepers and their families, sharing the limited water supply. The photograph suggests less than ideal living conditions. (Courtesy of the National Archives.)

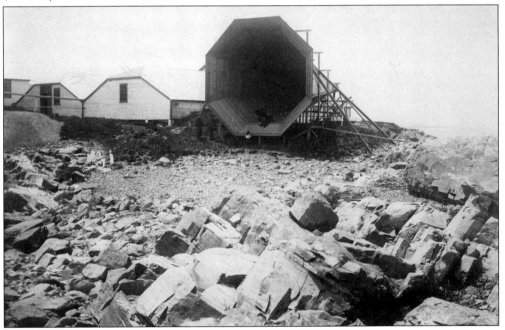

Steam engines were used during MIT's fog signal experimentations, requiring substantial quantities of water. To accommodate this, a second 21,800-gallon cistern with an accompanying rain shed was constructed. Both buildings are visible to the left of this huge trumpet-type fog signal apparatus. (Courtesy of James Claflin.)

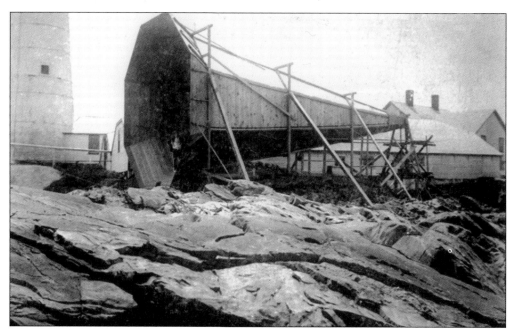

A unique phenomenon was reported by mariners when approaching Nantasket Roads during times of limited visibility. During certain atmospheric conditions, the sound that had been audible would subside and then return. The phenomenon was referred to as the "ghost walk." The students were tasked with developing and testing a variety of sound signal devices that were capable of penetrating through it. One of them was a steam-driven Daball trumpet that was 55 feet long, 17 feet wide, and had a 10-inch reed. In the photograph above, dated 1894, a man standing inside the trumpet emphasizes its enormous size. (Both, courtesy of the National Archives.)

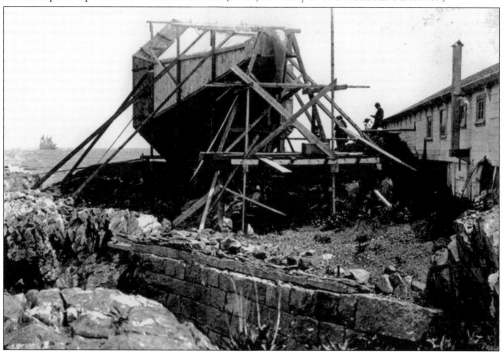

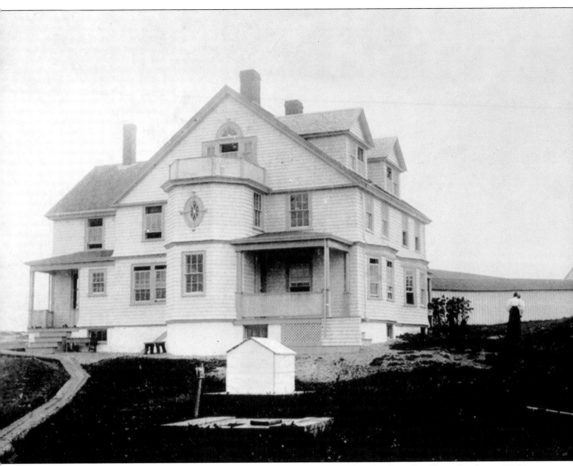

During Henry L. Pingree's tenure as principal keeper, the duplex dwelling built in 1859 was renovated to a Colonial Revival style. The 1895 project significantly altered the appearance of the original structure. Two separate front porch entrances, one on either end of the house, replaced the single front door. Three windows were added to the left side of the house, two on the first floor, one of which was a double window, and a third on the back entrance. The roof was raised to accommodate a third floor. The protrusion on the side of the dwelling was the interior stairwell with its roof line altered. A window was added to the second floor of the stairwell along with a veranda on the third floor with a handrail and an ornamental door. The connecting walkway to the tower would be gone within a year. The well house in the foreground continued to provide non-potable water for household use. Standing by the connecting walkway is a woman wearing a fashionable middy blouse. (Courtesy of the National Archives.)

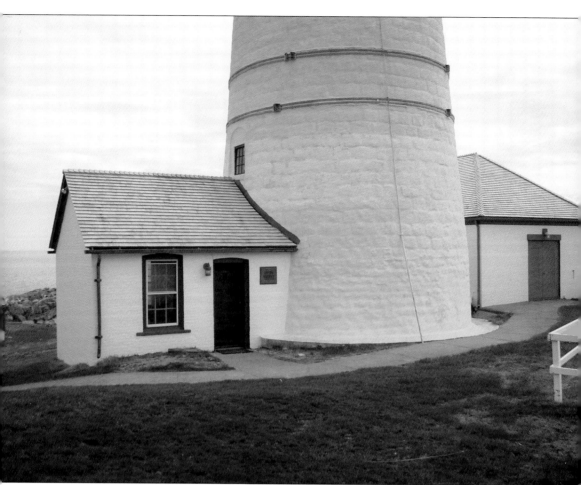

The duplex house was built in 1859 along with the brick oil room attached to the tower and a covered walkway connecting them. There were two entrances to the oil room, one through the enclosed walkway and the other via its front door. Henry Pingree, the 19th keeper (1895–1896), witnessed major renovations to the facilities. One of the changes was the removal of the covered walkway between the duplex and the oil room, significantly altering the profile of the east end of the island. The brick oil house constructed in 1889 on the south side of the island replaced the 1859 oil room as a storage space for flammable materials. The oil room was referred to as the "vestibule." With the walkway gone, its doorway was removed and replaced with a brick wall as seen here on the left side of the building. (Authors' collection.)

The boathouse is the newest structure on the island, constructed in 1899. The previous boathouse was situated on the south wharf closer to the shoreline. One of the worst recorded storms in New England's history ravaged the coastline on November 26 and 27, 1898. The seas washed away 100 feet of the south wharf along with the boathouse. The event is recalled by some as the "November Gale" and by others as the "Portland Gale" for the steamer *Portland*, which was lost at sea. There were numerous shipwrecks in Boston Harbor, including the three-masted schooner *Calvin F. Baker*, with a cargo of coal. The vessel sailed off course in blinding snow, grounding on the mussel bar between Little and Great Brewster Islands during the night. Keeper Pingree and the assistant keepers, unable to assist, hoisted a signal flag to Point Allerton Lifesaving Station in Hull to communicate the need for help. Capt. Joshua James and crew, arriving in one of their surfboats, were able to rescue three of the ship's crew. (Authors' collection.)

Two

LIGHTHOUSE KEEPING

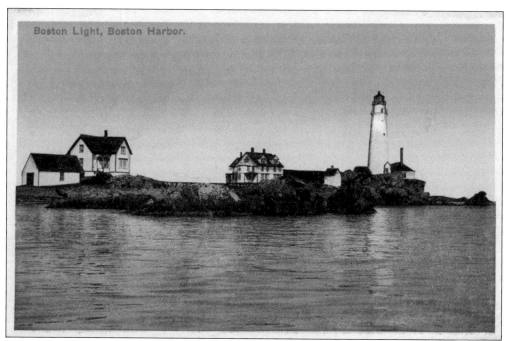

This postcard was postmarked on July 21, 1915. The photograph shows a southwesterly view of the island. From left to right are the boathouse, built in 1899; the principal keeper's house, built in 1884; the duplex, renovated in 1895; the oil house, built in 1889; the Boston Auxiliary Light, dating to 1890; the lighthouse tower, modified in 1858; and the fog signal building, altered in 1886. (Courtesy of Hugh Daugherty.)

Larger, powered ships were replacing sailing vessels in the late 1800s, resulting in the Narrows channel being too narrow. Another channel was dredged north of the Narrows in Broad Sound off the shores of Nahant and Winthrop. Entering the channel required passing Graves Ledges, a hazardous outcropping of rocks. Graves Light was constructed in 1903–1905 to show safe water into the new channel, located two miles north of Boston Light. The granite-block tower was 113 feet high with a huge first-order Fresnel lens. It was first lit on September 1, 1905. The ledges were named in honor of Rear Adm. Thomas Graves (1605–1653), a British seafarer who had explored the area in the early 1600s, not for the many sailors who had gone to their grave on the ledges. The lighthouse was automated in 1976. It is now privately owned by the Waller family. They are responsible for maintaining the structure; the Coast Guard continues to maintain the light and the fog signal. (Courtesy of James Claflin.)

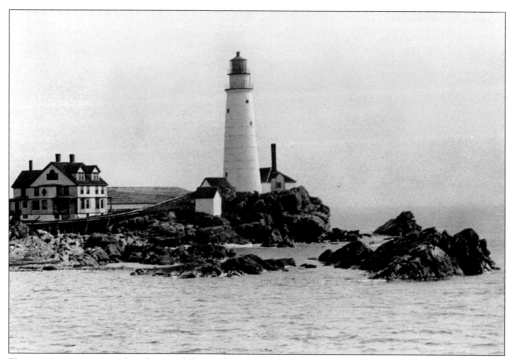

Twice a year, 40 tons of coal were delivered to the island to fuel the fog signal steam engine. These two c. 1918 photographs show a 700-foot trestle that ran from the wharf on the west end of the island to the coal storage shed adjacent to the fog signal building on the east end. The coal was transferred from the lighthouse tender to a car hauled along the trestle on the south side of the island. In 1927, Boston Light recorded that the fog signal apparatus operated continuously for 830 hours (approximately 35 days), using 44 tons of coal. (Above, courtesy of Jeremy D'Entremont; below, courtesy of James Claflin.)

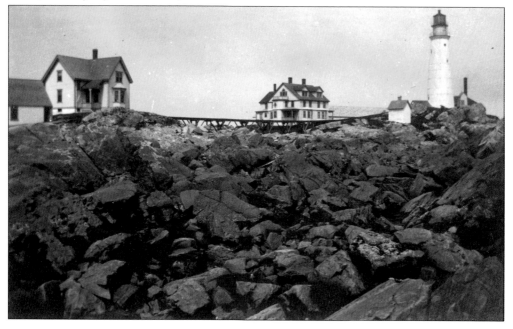

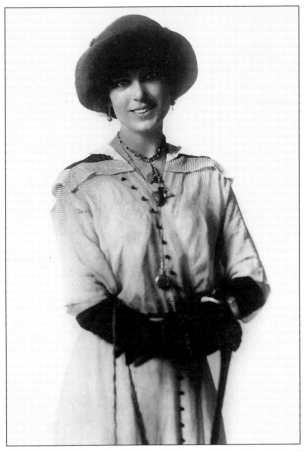

Harriet Quimby, the first woman in the United States to be issued a pilot's license, participated in the 1912 Boston Air Meet, where she offered passengers plane rides. At left, Quimby is wearing her distinctive purple flight suit; below, she is posed in her Blériot XI plane with a female passenger. A tragic accident prevented Quimby from competing in the race from Squantum Airfield to Boston Light and back. She and passenger William A.P. Willard, the organizer of the event, were returning from a flight to view Boston Light from the air. When returning to the airfield, the plane lurched downward, and both of them fell out, dropping 1,000 feet to their deaths. The many spectators and media witnessing the event were horrified. The event was cancelled, not to be held again. (Both, courtesy of Giacinta Bradley Koontz.)

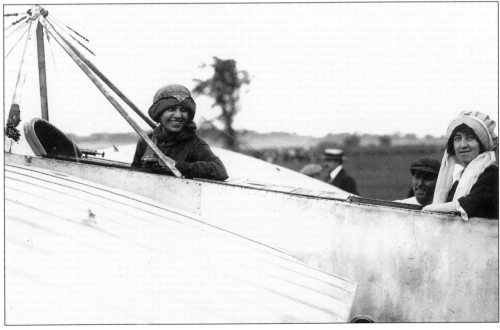

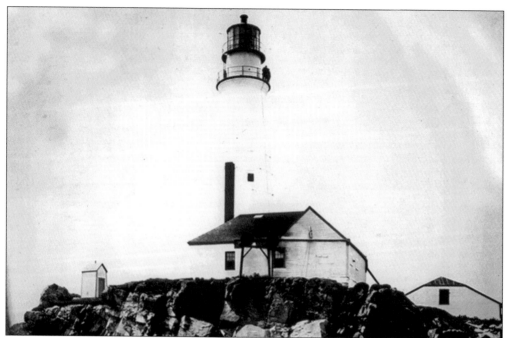

In 1914, a set of fog signal horns were mounted on the roof of the fog signal building supported by two posts, visible here. The sound was steam-generated, requiring large quantities of water. To the left is the Boston Auxiliary Light; to the right is the cistern building. (Courtesy of the National Archives.)

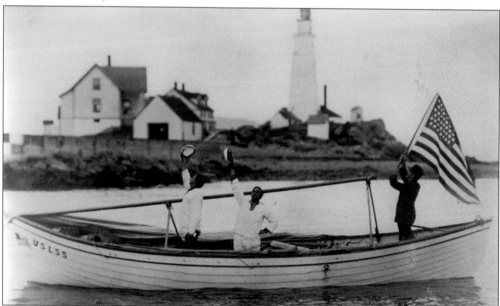

A Point Allerton Lifesaving Service rowing-sailing surfboat is close ashore to Boston Light with three crewmembers, two in white uniforms performing a hat salute and a third waving a large US flag. There is no reference to the occasion; however, a significant event occurred on August 4, 1915, when the Revenue Cutter Service and US Lifesaving Service were combined and named the US Coast Guard. (Courtesy of James Lampke.)

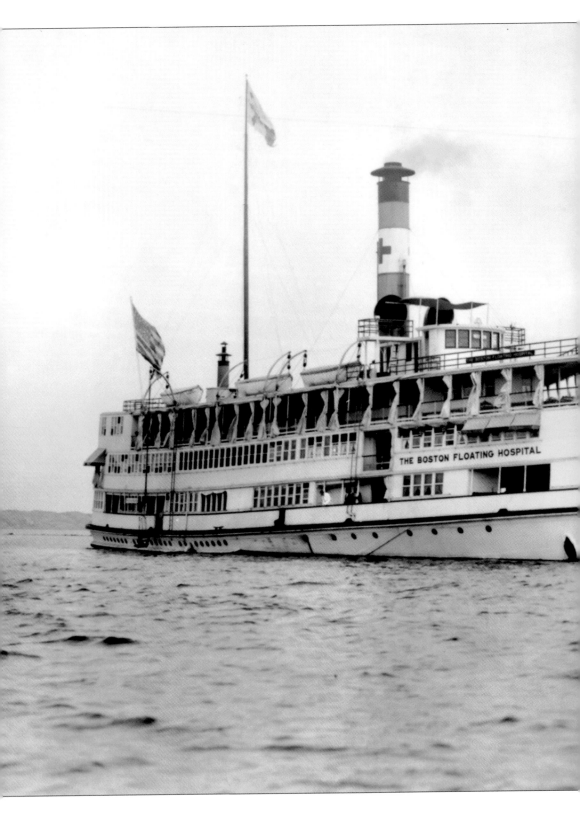

The Boston Floating Hospital was in service from 1894 to 1927, providing very sick children from the poorest sections of Boston with fresh air and sunshine. This population had the highest incidences of death during the hottest days of summer. The vision of the floating hospital came into fruition with a ship equipped with the most modern medical technology, doctors, nurses, and researchers. While escaping the hot and polluted environment of the city, the staff provided medical care for the patients and health education to the mothers. This c. 1917 photograph shows the floating hospital passing by Boston Light, exemplifying the unique humanitarian services of both, symbolizing hope for improved quality of life. Although no longer floating, the hospital continues today. (Courtesy of New England Medical Center Archives Collection, Tufts University, Digital Collections and Archives.)

BOSTON LIGHT
BUILT AT THIS PLACE
BY THE PROVINCE OF MASSACHUSETTS
WAS FIRST LIGHTED
SEPTEMBER 14 1716 OLD STYLE
DESTROYED 1776 AND REBUILT 1783

THIS TABLET HAS BEEN PLACED BY THE UNITED STATES LIGHTHOUSE SERVICE
SEPTEMBER 25 1916
IN COMMEMORATION OF THE TWO HUNDREDTH ANNIVERSARY
OF THE FIRST LIGHTHOUSE IN AMERICA

Boston Light's 200th anniversary celebration took place on the morning of September 25, 1916, at Little Brewster Island, commemorating the establishment of the first lighthouse in Colonial America. Transportation was provided by the lighthouse tender *Mayflower*. Greeting the entourage upon their arrival were principal keeper Charles Jennings and the two assistant keepers, Lelan Hart and Charles Lyman. Attendance was by invitation extended by the US secretary of commerce, William C. Redfield. The master of ceremony was the US commissioner of lighthouses, George Putnam, with four speakers expounding upon the history and valuable service provided by Boston Light. The main event was the unveiling of the commemorative plaque shown here. It was affixed to the inside wall of the tower entrance by the US Lighthouse Service and remains in place today. Tribute was given to the 23 Boston Light keepers who had served over the previous two decades. Following the ceremony, an inspection was made of the lens mechanism and fog signal apparatus, with the media taking photographs and movies. (Authors' collection.)

Although station boats were provided to each of the country's lighthouse stations, it was not unusual for the keepers to have personal boats as well. This c. 1928 photograph shows keeper Maurice Babcock's boat that he had while at Boston Light (1926–1941). Notice the condition of the north wharf on the right. (Courtesy of the Gatcomb family.)

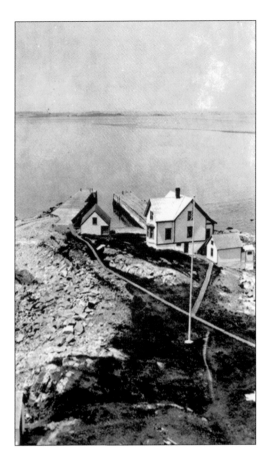

Maurice Babcock was the principal keeper when this photograph was taken on May 17, 1929. The two wharfs provide calm water for the station boat and visitors to safely land on the island. The 1899 boathouse sits in front of the piers. The principal keeper's house, barn, and outhouse are clearly evident as well. (Courtesy of the National Archives.)

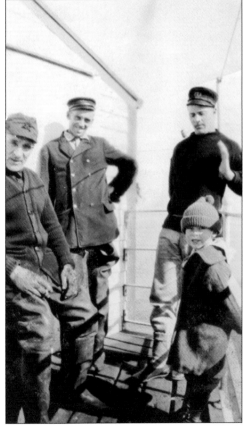

The individuals captured in this c. 1926 photograph at the Boston Light are, from left to right, unidentified, Babcock wearing the lighthouse service uniform, assistant keeper Arthur Small wearing civilian attire with the lighthouse service uniform hat, and Small's son, Jimmy. (Courtesy of the Gatcomb family.)

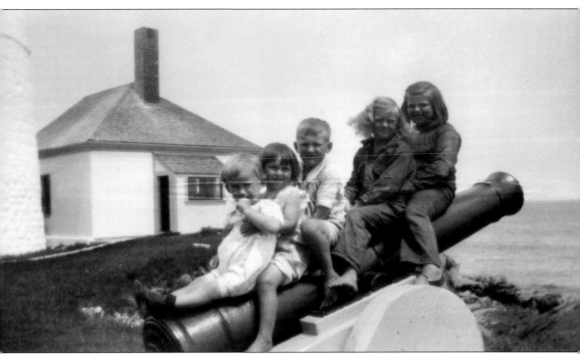

Second assistant keeper Ralph Norwood arrived for duty at Boston Light in November 1929 with his wife, Josephine, and five children. The children are posed in this 1930 photograph sitting on the retired 1719 fog signal cannon. From left to right are LaForest Gail (age 2), Lila Fay (age 5), Horatio Bruce (age 6), Wanda (age 7), and Priscilla (age 8). When Norwood joined the Lighthouse Service in April 1929, he was first stationed as an assistant keeper at Great Point Light on Nantucket. Six months later, he was transferred to Little Brewster Island, where the number of children would increase to nine. In 1938, Norwood was promoted to first assistant keeper. He was appointed principal keeper in October 1941, transitioning from the civilian Lighthouse Service position to a first class petty officer in the US Coast Guard. In 1945, he was transferred to Ram Island, Maine. (Courtesy of Willie Emerson.)

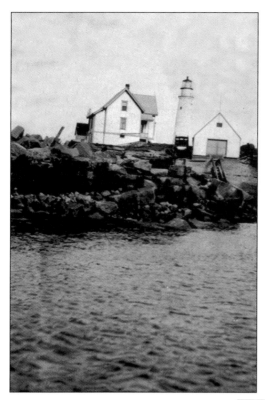

Spring storms are typical on the coast of New England. On March 4, 1931, a nor'easter did severe damage to both piers, with the north wharf suffering the worst. In the photograph at left, the stones that were once contained in the foundation of the wooden pier were strewn in such a manner as to block access to the boat railway. Below, a crane has been brought to the island to remove the debris from both piers and stones from the boat railway. Reconstruction of the wharfs could not occur until the clearing process was completed. Keeper Babcock's family boat is visible, stowed to the left of the boathouse. (Both, courtesy of the National Archives.)

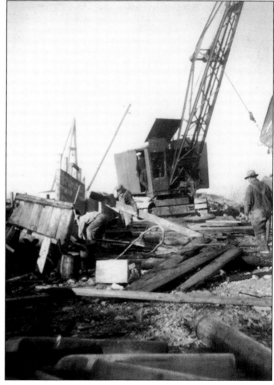

Illustrated in these two photographs is the result of the March 4, 1931, nor'easter. The seas dislodged the stones that were once contained within the foundation of the north pier and redeposited them onto the bottom of the railway. The boat could not be launched until the stones were removed and damage to the rails repaired. The photograph below shows the amount of destruction that occurred to the north pier, with most of it being gone. Wooden planking washed from the pier was left high on the beach as the tide receded. (Right, courtesy of the National Archives; below, courtesy of the US Coast Guard.)

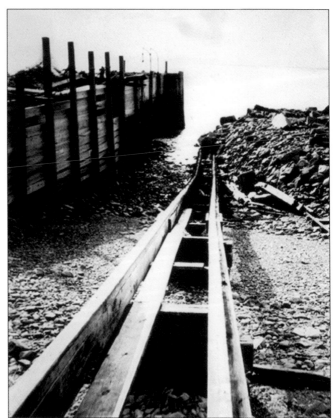

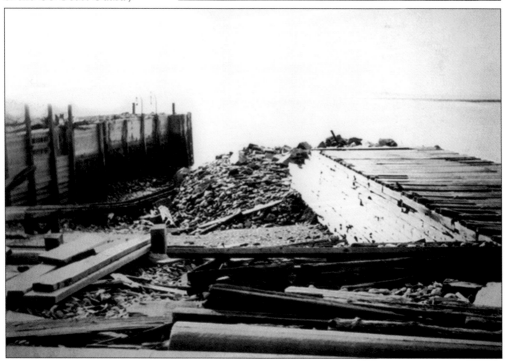

This is a classic display of boys being boys, with Bruce Norwood (age 7) holding his brother, Gail (age 3), in a neck lock as they play for the camera in 1931. Visible in the left background is the window that had been installed in the loft of the boathouse around 1915. Three fuel oil tanks sit behind the boathouse. (Courtesy of Willie Emerson.)

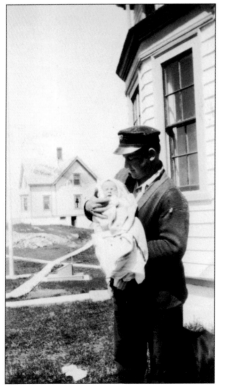

On April 11, 1932, Georgia Norwood was born to second assistant keeper Ralph Norwood and Josephine Norwood at Little Brewster Island at 4:00 a.m. US Coast Guard Station Point Allerton brought Dr. Walter H. Sturgis from Hull to the island for the delivery. The event, occurring at the lighthouse, made national news. Here, Norwood is posing with his baby daughter. (Courtesy of Willie Emerson.)

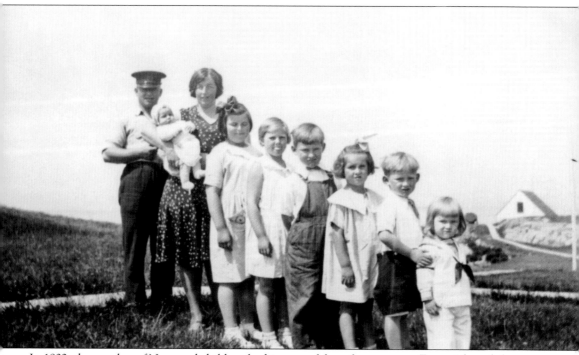

In 1932, the number of Norwood children had increased from five to seven. From right to left are Ralph Jr. (age 2), Gail (age 4), Fay (age 6), Bruce (age 8), Wanda (age 9), Priscilla (age 10), mother Josephine holding baby Georgia, and second assistant keeper Ralph Norwood. Two more children would arrive over the next three years. In 1986, Norwood's grandson Willie Emerson published a memoir of the family's firsthand accounts of 15 years at Boston Light, such as Georgia Norwood's birth on April 9, 1932. Another memory was an older child looking after a younger, tethering them with a rope around the waist. The rope would be yanked to pull the young one away from forbidden areas. One of keeper Maurice Babcock's five children recalled the abundance of rats on the island. The lighthouse inspector disallowed poisoning the rats because they frequently got into the house cisterns. Poisoned rats would contaminate the water, requiring the cisterns to be drained and bleached. (Courtesy of Willie Emerson.)

This is another photograph of the seven Norwood children taken in 1932 on the front porch. They are, from left to right, Bruce (age 8), Ralph Jr. (age 2), Wanda (age 9), Priscilla (age 10) holding baby Georgia, Gail (age 4), and Fay (age 6). Behind them is a hammock and a glimpse of the lace curtains and steam radiator visible through the window. Norwood, the lowest ranking keeper on the island, was assigned to the right side of the duplex house, closest to what could be the annoying fog signal. The first assistant keeper resided in the left side of the duplex, somewhat buffered from the sound. The fog signal was less audible in the principal keeper's house, located farthest away on the west end of the island. Although the children were not allowed to climb the tower, they would beg to go. Norwood would occasionally, and discretely, take one child at a time to accompany him when he lit the light. (Courtesy of Willie Emerson.)

The two wharves made for calm waters for children to practice rowing skills. Maurice Babcock Jr. is rowing a friend, Jeanette Fitzpatrick, whose family was visiting the Babcocks. The deteriorating north wharf shown on page 51 had been replaced with a new steel foundation around 1930. (Courtesy of the Gatcomb family.)

This 1933 photograph shows the two youngest Norwood children, Ralph Jr. (age 3) and Georgia (age 14 months). The cart they are sitting in has a line attached at the front to be pulled around the island under ever-watchful eyes. The flag pole to the left marked first base for the older children when playing a miniature form of baseball. (Courtesy of Willie Emerson.)

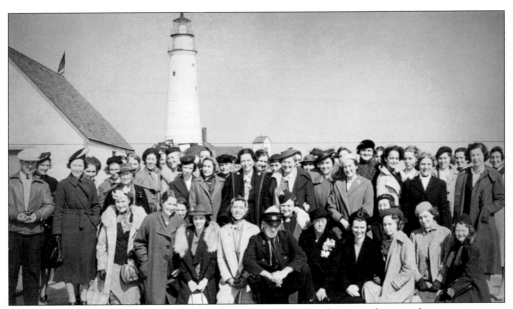

This c. 1937 postcard has no caption. It shows keeper Babcock sitting front and center amongst more than 42 women. It was unusual to have such a large number of guests on the island and further remarkable for them to be all women. Although it was made into a postcard, no reference to the event could be found. (Courtesy of the Gatcomb family.)

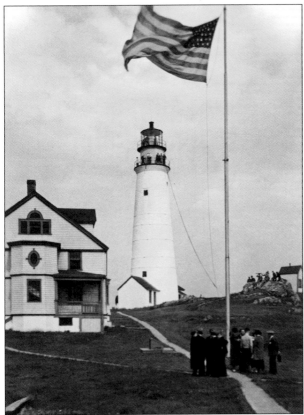

On Sunday, June 5, 1938, many guests attended a gathering at Little Brewster. There are as many as 10 assembled by the flagpole, with another 10 or more at the top of the tower. Seven are on the rocks to the right by the oil house. (Courtesy of the Gatcomb family.)

The Bostonian Society and the
Massachusetts Historical Society
sponsored a celebration on December
2, 1934, memorializing the first 25
keepers of Boston Light. A tablet
was unveiled by Fitz-Henry Smith
Jr. in the vestibule at the entrance
to the tower. Those at right are,
from left to right, past keepers James
Lelan Hart (1919–1926) and Charles
Jennings (1916–1919), keeper Maurice
Babcock Sr. (1926–1941), and Fitz-
Henry Smith Jr. Other guests not
shown were Prof. Robert Moody
of Boston University and Edward
Rowe Snow. Today, the whereabouts
of this tablet are unknown. (Right,
courtesy of Jeremy D'Entremont from
the Edward Rowe Snow Collection,
with permission of Dorothy Snow
Bicknell; below, courtesy of the US
Coast Guard Historian's Office.)

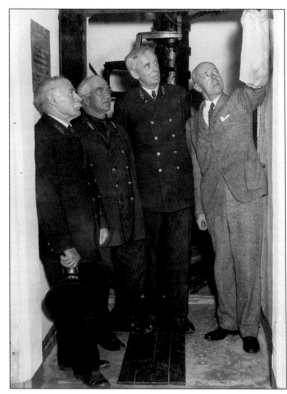

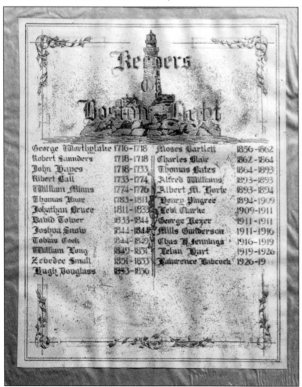

Keepers of Boston Light		
George Worthylake	1716–1718	
Robert Saunders	1718–1718	
John Hayes	1718–1733	
Robert Ball	1733–1774	
William Minns	1774–1776	
Thomas Knox	1783–1811	
Jonathan Bruce	1811–1833	
David Tower	1833–1844	
Joshua Snow	1844–1844	
Tobias Cook	1844–1849	
William Long	1849–1851	
Zebedee Small	1851–1853	
Hugh Douglass	1853–1856	
Moses Bartlett	1856–1862	
Charles Blair	1862–1864	
Thomas Bates	1864–1893	
Alfred Williams	1893–1893	
Albert M. Horte	1893–1894	
Henry Pingree	1894–1909	
Levi Clarke	1909–1911	
George Bezer	1911–1911	
Mills Gunderson	1911–1916	
Chas H. Jennings	1916–1919	
Lelan Hart	1919–1926	
Lawrence Babcock	1926–19	

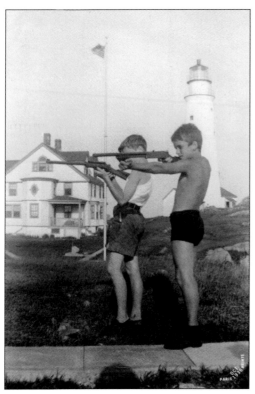

The two 12-year-old boys with rifles at left are Bruce Norwood (left) and Maurice Babcock Jr. Remnants of the well remain visible on the ground, used for refrigeration. The keeper was said to have chilled his butter and other perishables by placing them in a bucket and lowering it into the well. Below, keeper Babcock is in civilian attire, looking contemplative while resting a foot on a wharf post. At ground level to his left is the boat railway leading to the entrance of the boathouse with its sliding barn doors. (Both, courtesy of the Gatcomb family.)

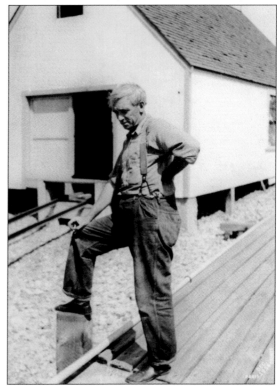

HULL CHILD OFF FOR FILM CAREER

Georgia Norwood, 5, Only Girl Ever Born on Lighthouse, Already Has Two Movie Offers

HEADED FOR HOLLYWOOD
Georgia Norwood, born in a lighthouse, who is starting for Hollywood for a movie career.

Georgia Norwood's birth at Boston Light in 1932 made national news. Inspired by this event, in 1937, novelist Ruth Carman published *Storm Child*, a drama involving an island lighthouse. At age five, Norwood went on tour with Carman to promote the book and potential movie. In 1938, Norwood was scheduled for a Hollywood screen test for appearances in the movie. However, she preferred Boston Light to a trip to the west coast. The movie was never made. As an adult, Norwood married and raised a family. Her son, Willie Emerson, learning of his mother's childhood media adventure and intrigued by life on an island lighthouse, interviewed his family members. In 1986, Emerson published *First Light: Reminisces of* Storm Child *and Growing up on a Lighthouse*, a compilation of the interviews. (Both, courtesy of Willie Emerson.)

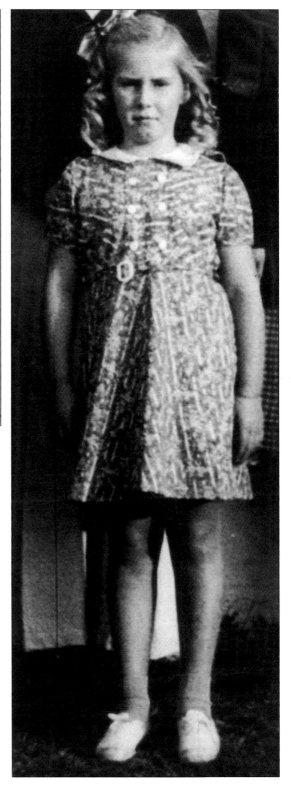

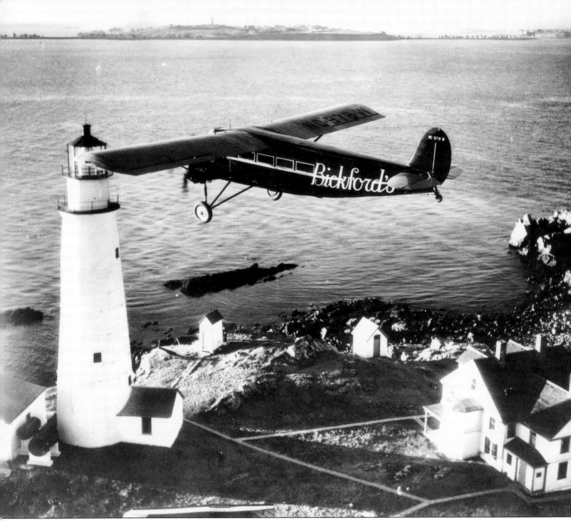

Delivering Christmas gifts to lighthouses is a New England tradition begun in 1929 by Capt. William Wincapaw. He flew a float plane, making deliveries to the numerous islands in Penobscot Bay, Maine. Lighthouse beacons were invaluable to him and other pilots as navigational aids, especially in poor visibility. To express his appreciation to the keepers and their families for keeping the lights burning, at Christmastime, he began delivering simple gifts of candy, coffee, magazines, and the like. Before long, he acquired the nickname of "Flying Santa." His flights expanded along the coast of Maine, with his son, William Jr., helping out. When flights extended to Massachusetts, Edward Rowe Snow was recruited to help out. This December 25, 1937, aerial photograph shows a delivery about to be made to the families residing at Boston Light. The name "Bickford's" on the plane is for the Bickford's restaurant chain. Through the efforts of the Friends of Flying Santa Inc., the tradition continues today via helicopter landings at Coast Guard stations and lighthouses. (Courtesy of James Claflin.)

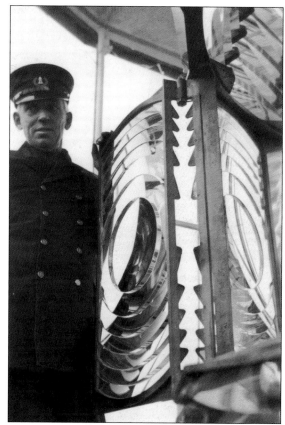

In 1913, the illuminating apparatus of the classical Fresnel lens installed in 1859 was upgraded with an incandescent oil vapor (IOV) lamp. These two pictures, dated March 11, 1938, show keeper Babcock tending to the apparatus in his dress uniform. For easy access into the lens, two of the 12 bull's-eye panels are hinged for opening. At right, Babcock is standing in the lantern room with one of the panels open. Typically, a dress uniform would not be worn for such a task, suggesting that a special event or photograph opportunity was occurring on the island. Below, the keeper is inside the lens demonstrating how to operate the apparatus. (Both, courtesy of the Gatcomb family.)

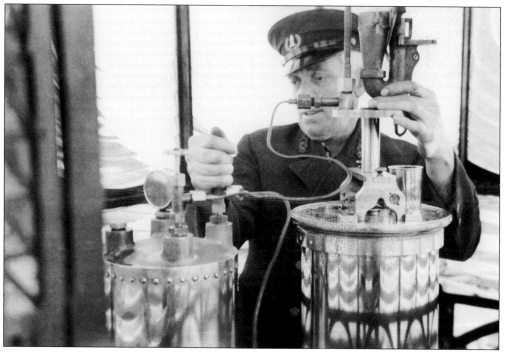

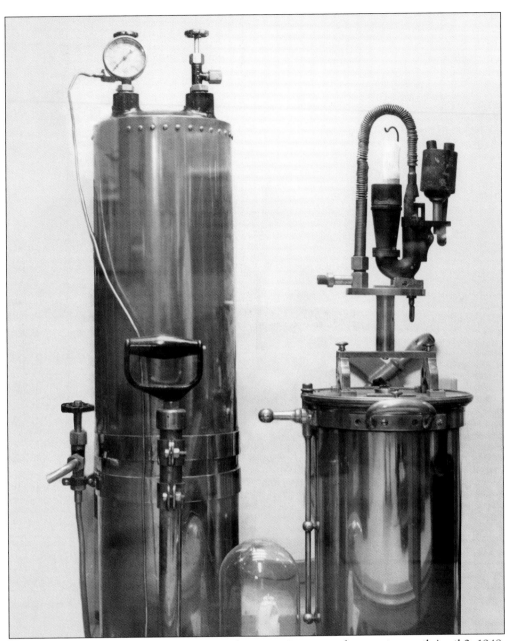

Boston Light's IOV lamp, first lit on September 1, 1913, remained in service until April 2, 1948, when it was replaced by an electric lamp. It was similar to today's camp lamps only much larger. The tank to the left contained kerosene as the fuel source for the lamp. The handle in front was used to pump air into the tank. The kerosene under pressure was then heated to produce a gaseous vapor. A mantle, seen on the top of the right tank, was made of silk and would absorb the vapor. When lit, it created a very bright white light. The mantle was very fragile, requiring much care when lighting it. To keep pressure in the tank, the handle needed to be pumped every three to four hours. From December 7, 1941, to July 21, 1945, during World War II, the main optic was extinguished. However, the fog signal and Boston Auxiliary Light remained in service. (Authors' collection.)

In this c. 1938 photograph, keeper Babcock and his wife, Mary Babcock, appear to be enjoying a relaxed moment on the front steps of the 1884 principal keeper's house. By comparing this photograph to previous ones, it is noticeable that the porch has been enlarged and enclosed. (Courtesy of the Gatcomb family.)

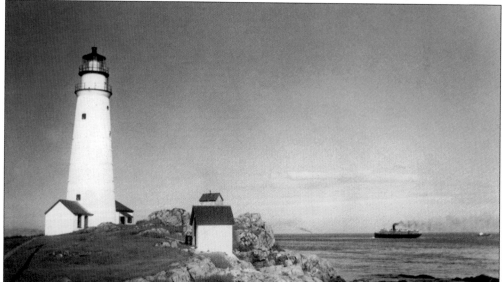

This c. 1938 photograph labeled "Steamer" shows a ship passing the island. Keepers Babcock and Norwood were astute about vessel types—military, commercial, and recreational—and paid attention to their movements in the outer harbor. They encouraged their children to do the same. Today, the US Coast Guard refers to this vigilance as "situational awareness" and expects all personnel to practice it. (Courtesy of the Gatcomb family.)

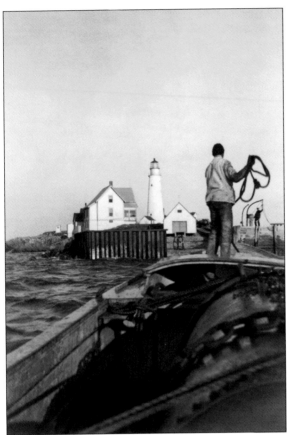

By 1930, the island had begun utilizing fuel oil for the fog signal machinery, cutting coal consumption from 40 tons per year to 20 tons. It is presumed that both dwellings remained heated by coal. Both of these photographs are dated March 1938 with the oil boat approaching the south wharf to make a transfer. The picture on the left shows the rebuilt north wharf and a crewmember on the bow of the vessel prepared to toss a line to personnel on the south wharf. Below, there are three large fuel storage barrels sitting to the right of the boathouse. Two additional barrels, not visible, are situated at the east end of the island between the fog signal building and the tower. Notice the station's dory sitting on the railway outside the boathouse. (Both, courtesy of the Gatcomb family.)

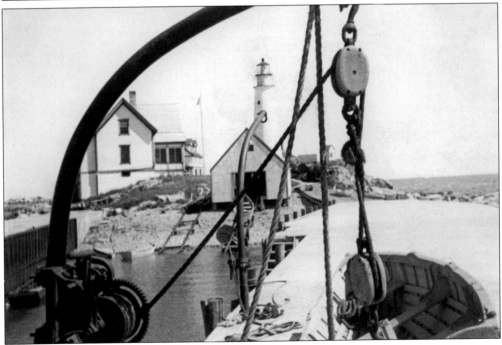

Flying Santa visited Boston Light around 1938 via the lighthouse tender rather than dropping the gift bundle from an airplane, significantly improving the chances of its contents arriving in good condition. Onboard the vessel accompanying Santa (Edward Rowe Snow) is keeper Babcock to his right. The children's names and their relation to Babcock or other keepers are unknown. (Courtesy of the Gatcomb family.)

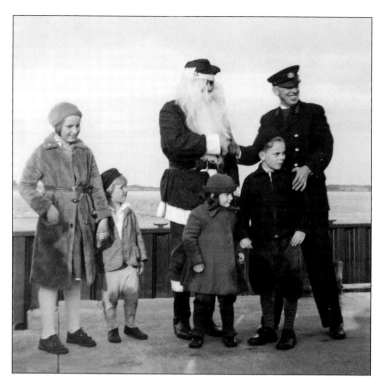

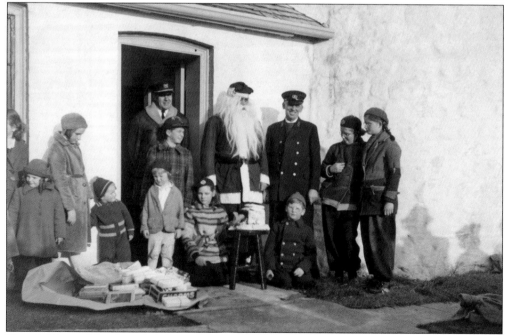

The children of the three lighthouse families living on Little Brewster gathered at the entrance to the tower. A brown paper bundle of goodies is lying open on the ground. The three adults standing by the door are, from left to right, an unidentified captain of the lighthouse tender, Edward Rowe Snow as Santa, and keeper Babcock. The children are unidentified. (Courtesy of the Gatcomb family.)

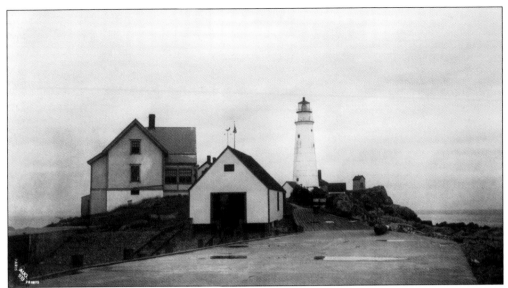

This is a c. 1938 view of the island looking from the pier eastward. The first building is the boathouse, the newest structure (1899). The principal keeper's house (1884) is to the left with a newly enclosed porch. The duplex chimneys are visible between the two buildings. The tower (rebuilt 1783) is in the background, and the Boston Auxiliary Light is on the far right. (Courtesy of the Gatcomb family.)

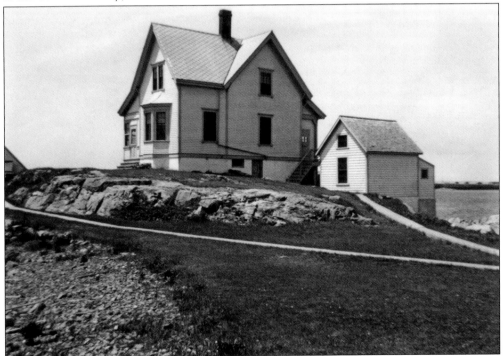

The principal keeper's house is shown around 1938 with a detached barn. It has an outhouse attached to the back. Notice the rain spout that runs vertically from the roof down the side of the house. As it approaches the cellar, the spout runs horizontally to the right and into the 2,200-gallon cistern. (Courtesy of the Gatcomb family.)

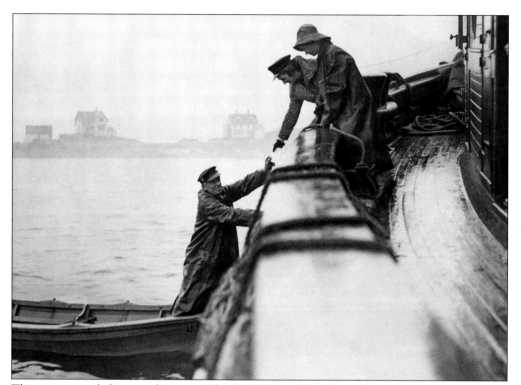

This was a staged photograph arranged by the US Postal Service to demonstrate its commitment to deliver to any location in any weather. Keeper Babcock is in the light station's dory reaching to receive the mail from his wife, Mary Babcock, onboard the lighthouse service tender. A witness to the delivery is their daughter, Grace Babcock. (Courtesy of the Gatcomb family.)

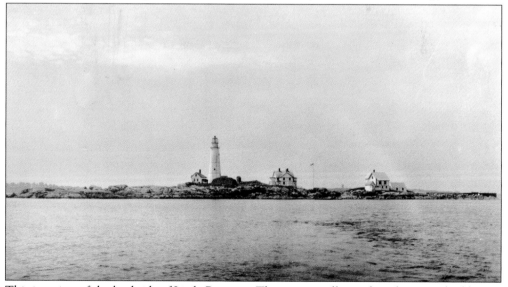

This is a view of the backside of Little Brewster. There is a small, weathered exterior building to the right of the tower that is not identifiable, changing the profile of the landscape. The low, dark structure in front of the tower is the rain shed. The structure in question is to its right. (Courtesy of the Gatcomb family.)

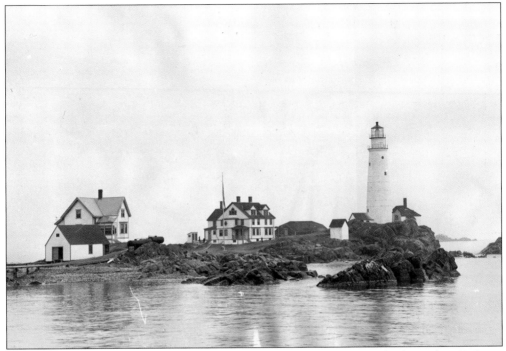

This photograph is dated 1939, the year the Lighthouse Service was absorbed into the US Coast Guard. Also in 1939, the Norwood family rented a house in Hull to ensure their school-aged children attended school on a regular basis. Assistant keeper Norwood remained on the island. His wife, Josephine, and nine children returned to the island for summers, weekends, and holidays. (Courtesy of James Claflin.)

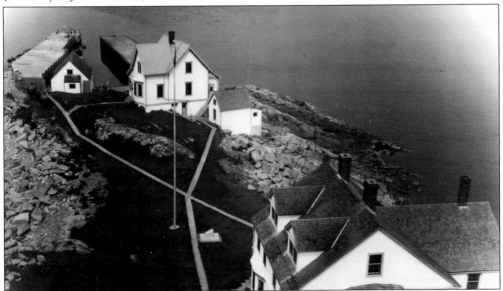

This low-altitude aerial view of Little Brewster around 1940 looks quite serene. The water is calm, and the flag hangs at rest on the flagpole. On the left, both piers have been repaired from the damage done by the Great New England Hurricane of September 1938. (Courtesy of Jeremy D'Entremont.)

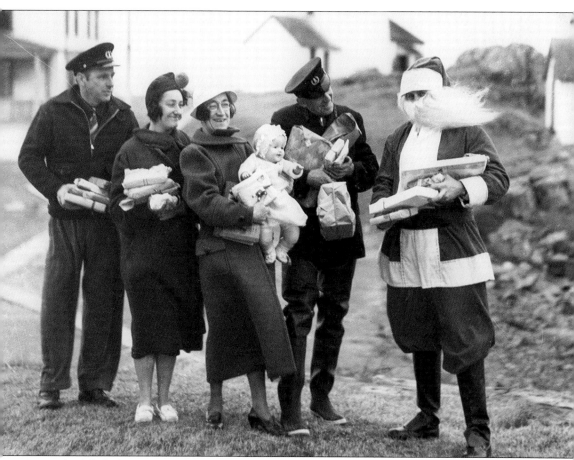

On a scheduled Flying Santa delivery day, multiple lighthouses and lightships along the coast would receive their bundles dropped from the plane. Ideal weather and wind conditions were required for successful drops. The pilot needed to be able to maintain control of the plane at all times when approaching low and slow toward the target. Little Brewster was a bigger and easier target than a lightship or a lighthouse protruding from the sea, such as Graves Light. In December 1939, conditions were unsafe for flights, resulting in Santa making his Boston Light delivery by boat. This photograph of adults only was due to the strong winds making it unsafe for excited young children to be on the grounds. Santa's beard blowing 90 degrees from his chin testifies to the strength of the north wind. Posing for this picture are, from left to right, second assistant keeper Osborne E. Hallett; his wife, Frances Hallett; keeper's wife Mary Babcock; keeper Maurice Babcock; and Edward Rowe Snow as Santa. (Courtesy of Jeremy D'Entremont.)

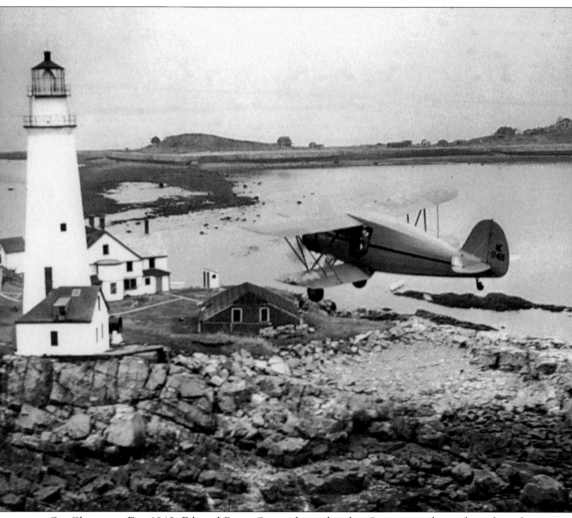

On Christmas Eve 1940, Edward Rowe Snow, dressed in his Santa suit, drops the gift package from the open door of the plane, targeted to land on the stony beach below. The bundle can be seen in midair just below the plane between the lower wing and the tail. The calm water is an indicator of favorable wind conditions, increasing the probability of the package landing on the beach rather than in the bay. It was low tide, making for a larger target. There have been occasions when packages landed in the water, sometimes salvageable, other times not. A postcard was included in the gift package for the keepers to report the condition of the package contents. If the package was unretrievable or the gifts damaged, Snow would replace the gifts whenever possible, months later if need be. (Courtesy of Friends of Flying Santa Inc.)

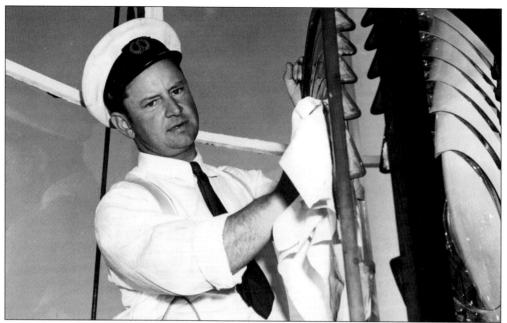

The above photograph, dated September 14, 1941, shows first assistant keeper Ralph Norwood cleaning one of the 12 bull's-eye exterior panels of the Fresnel lens. Below, the upper interior prisms are being cleaned. In October 1941, principal keeper Maurice Babcock made his mark in the annals of Boston Light history as the last Lighthouse Service civilian keeper. Norwood, stepping into the keeper's position, took an enlistment as a first class boatswain's mate in the Coast Guard as the officer in charge of Light Station Boston. In 1939, the Lighthouse Service was absorbed into the Coast Guard, with civilian keepers gradually integrated into active-duty military assignments. In 2003, the position again became a civilian appointment within the Coast Guard. (Both, courtesy of the US Coast Guard Historian's Office.)

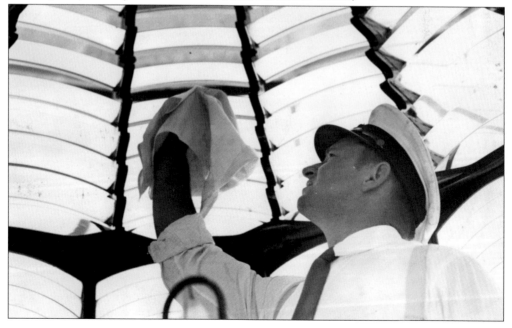

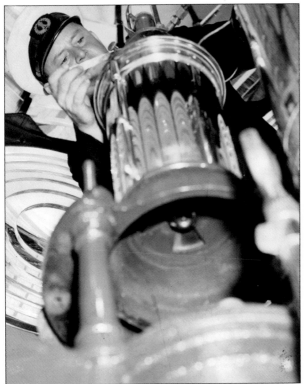

Assistant keeper Norwood, inside the 11-foot-tall lantern, demonstrates the workings of the IOV lamp that had been in service since 1913. The lamp burned refined kerosene oil. When heated, the oil became vaporized, transforming into a gaseous flame that ignited the mantle, producing an extraordinarily bright and clear light. It was in use until electrified in 1948. (Courtesy of the US Coast Guard Historian's Office.)

This is the duplex house as it appeared on September 14, 1941, for the 158th commemoration of the lighthouse tower's 1783 reconstruction. The 1859 two-story duplex structure was renovated to a Colonial Revival style in 1895. In the cellar, each of the two units had its own cistern for collecting water from the roof. (Courtesy of the US Coast Guard Historian's Office.)

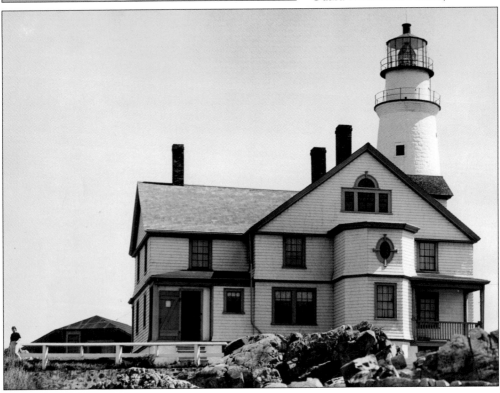

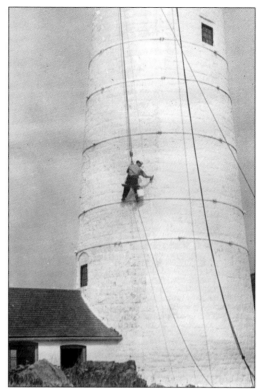

Painting the exterior of the structures during warmer months and the interior in the winter was a never-ending task. The 1945 photograph at right shows a Coast Guardsman, possibly keeper Julio DiFuria, suspended from a boatswain's chair, an apparatus comprised of a rope pulley system suspended from the handrail of the first deck. A wooden plank is used as a seat with a hook on its side for hanging the paint bucket. A rope attached to the seat is a tether for a person on the ground to assist in controlling the chair. The ropes of the boatswain's chair pulley are clearly visible. Below, a military helicopter passes close to the lantern room. (Right, courtesy of Jeremy D'Entremont; below, courtesy of the US Coast Guard Historian's Office.)

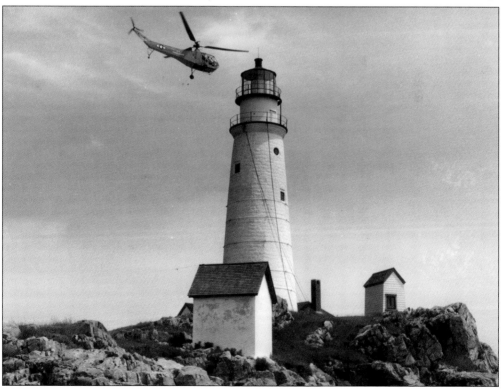

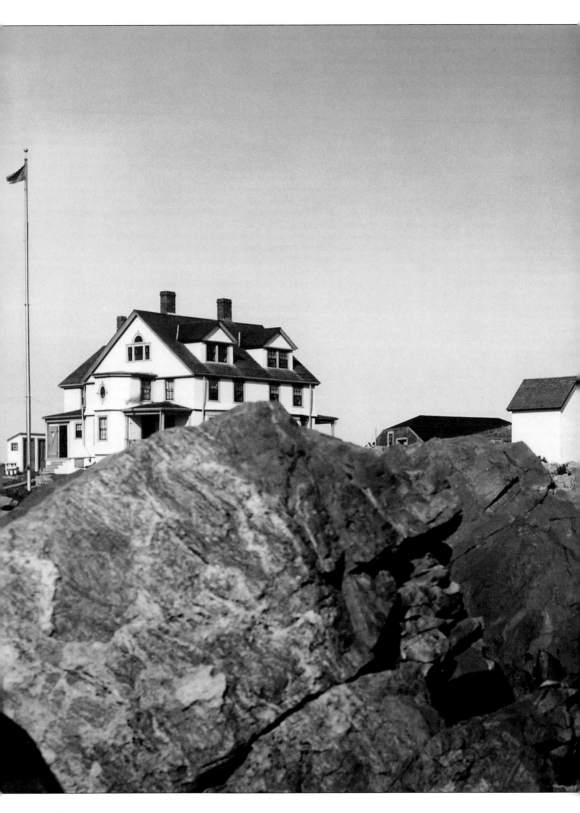

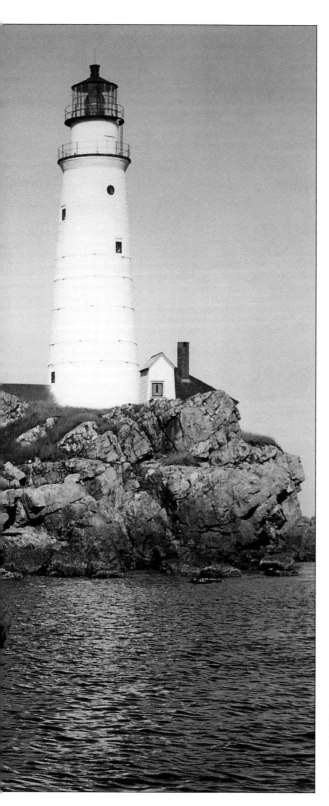

On September 14, 1941, a modest commemorative ceremony was held for the 225th anniversary of Boston Light and the 158th year of the tower's reconstruction in 1783 at the conclusion of the Revolutionary War. The event was documented more with photographs than in words. Visible are, from left to right, the flagpole, duplex outhouse, duplex house, the weathered shingled rain shed (cistern building), the oil house in the foreground, the lighthouse tower, Boston Auxiliary Light, and the chimney of the fog signal building. This perspective of the island with its foreboding rocky shoreline gives evidence for the need for an aid to navigation. (Courtesy of the US Coast Guard Historian's Office.)

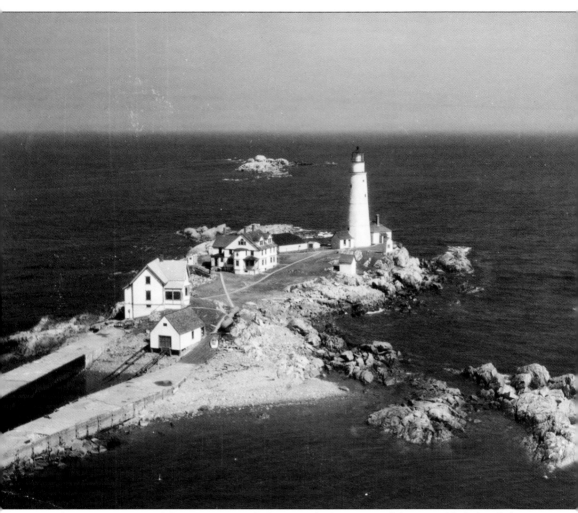

Close examination of this c. 1945 aerial photograph shows a small barn visible behind the rain shed and a wire fence running between the southwest corner of the rain shed and the vestibule room at the base of the tower. The barn could have been for one or more goats, a practical source of fresh milk. In the background sits Shag Rocks, a ledge that resulted in many shipwrecks. Its name was derived from the cormorants that nested there, referred to locally as "shags." During a severe winter storm on February 25, 1900, the tugboat *Otto*, towing the coal barge *Keystone*, wrecked on the rocks. The tug was able to work itself free and rescue the crew from the barge. The tug, with the crew of the barge, sought refuge at Boston Light until the storm passed. The coal barge was ravaged by the sea and could not be salvaged. (Courtesy of US Coast Guard Historian's Office.)

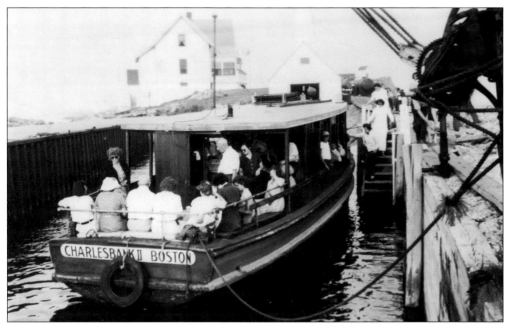

Edward Rowe Snow had a strong following among those with a thirst for maritime history and lore. In the 1940s, he provided opportunities for others to accompany him on island adventures. They called themselves the "Ramblers" and would frequently ramble to Boston Light. The 1947 photograph above shows passengers onboard the charted vessel *Charlesbank II*. The island was accessed via the wooden steps to the right. Boarding and disembarking the boat required a bit of agility and situational awareness. The photograph below, dated 1949, shows picnickers tucked behind a large stone on the southeast portion of the island, protected from winds that average 20 miles per hour. A portion of the duplex house is visible to the left. (Both, courtesy of the Hull Lifesaving Museum.)

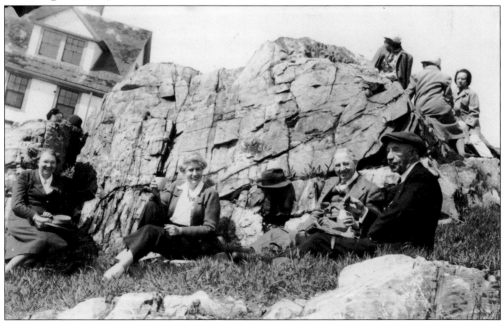

Many children who grew up at Boston Light in the 1930s and 1940s have documented their stories of island living. Swimming experiences are usually included in their tales. Captured in this c. 1940s picture are activities taking place in calm waters between the two protective wharfs. In the foreground are three older teenagers enjoying themselves in the station's dory. In the water are two swimmers wearing bathing caps on their heads. On the right, three children are watching from the wooden steps with an adult keeping a watchful eye. Edward Rowe Snow was on the island as well, acquiring his own experiences to write and talk about. Noticeable are two sets of boat rails on the beach. One leads into the boathouse for stowing the station boat; the other, on the left, was used for hauling keeper Babcock's family boat out of the water. In the foreground on the right is a hoist on the pier for unloading equipment and supplies from the lighthouse tender. (Courtesy of the Hull Lifesaving Museum.)

Three

TRANSITION YEARS, 1950–1959

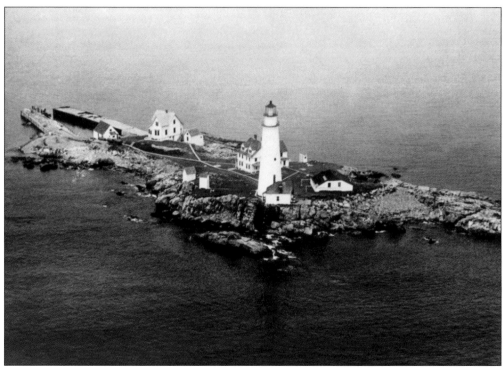

Preparation took place during the 1950s for major changes that would occur in 1960. This aerial view shows, from left to right, wharfs in disrepair, the boathouse, the keeper's house with its barn and outhouse, the duplex house, the tower, and the fog signal building. To the right of the tower is the rain shed with two clothesline poles visible; at left are the oil house and Boston Auxiliary Light. (Courtesy of the US Coast Guard.)

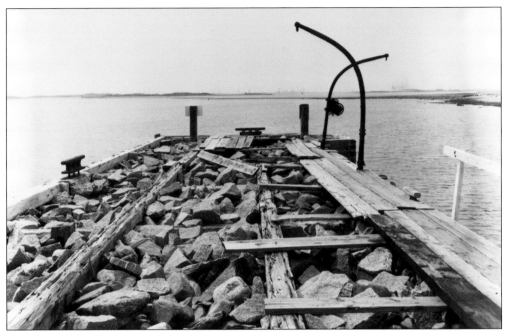

The piers at Little Brewster sit precariously exposed and vulnerable to the assault of winter and spring storm surges that result in costly repairs. These two photographs, taken on May 4, 1950, show the extent of such damages. Above, most of the wooden planking that would have otherwise covered the stone of the south pier is gone. The steel cleats and steel hoists have been left in place, although their integrity may have been jeopardized. Below, the north pier has had its concrete broken into large chunks and pulverized by the stormy sea. The back of the keeper's house and boathouse do not appear to have sustained much damage. (Both, courtesy of the US Coast Guard.)

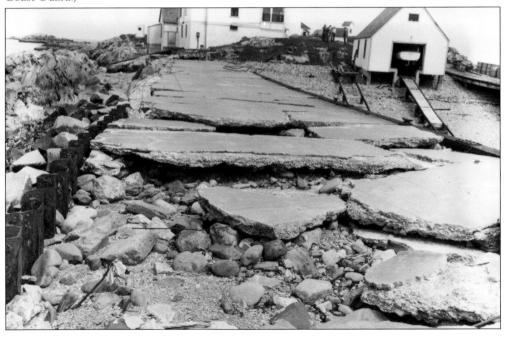

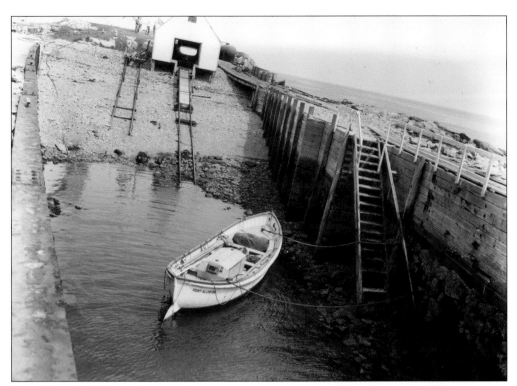

Dated May 4, 1950, the photograph above shows the boat railway with the station boat hauled and stowed in the boathouse. There is a second railway on the left that was available for a second station boat or the keeper's personal boat. A gasoline engine, seen at right, hauls the boat into the boathouse. A Coast Guard Station Point Allerton boat from Hull temporarily sits in the calm water between the north and south piers. While the crew and passengers visit, the boat is tied off to the handrail of the wooden steps. At the time, keeper Joseph Lavigne was the officer in charge of Boston Light. (Above, courtesy of the National Archives; right, courtesy of the US Coast Guard.)

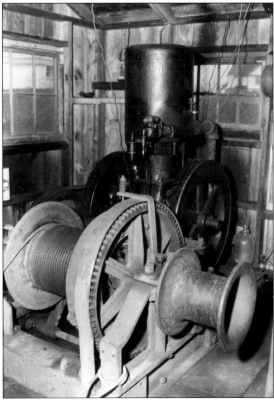

On May 4, 1950, no indoor plumbing existed in either house. Each family had a designated outhouse for its own use. The principal keeper's outhouse was attached to the barn. The assistant keepers' duplex house had a duplex privy. The family on the left side of the house was designated the sole user of the left privy, and the family of the right side of the house had exclusive use of the right privy. Infringement on another's outhouse was cause for negative repercussions from the keeper and ill will amongst the families. The privies were set on the ledge behind the houses, with the effluent discharged directly into Massachusetts Bay. During the summer, an abundance of flies would facilitate quick use of the facilities; in the winter, use was expedited by the cold. Keeper Lavigne did not appreciate his outhouse and installed a toilet in the cellar. It was flushed with rain water collected in three 50-gallon drums and emptied directly into the sea. (Courtesy of the National Archives.)

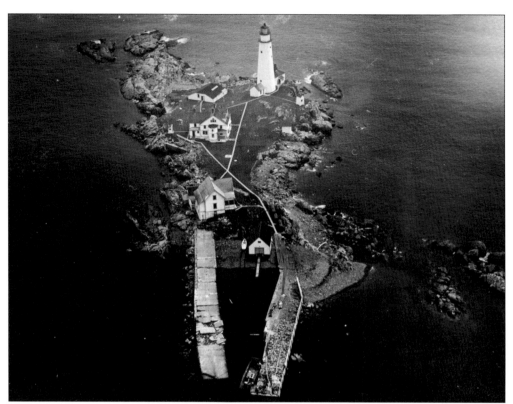

This c. 1950 aerial view shows storm damage to the piers. To economize, consideration was given to replacing both of piers with mounds of rocks as breakwaters and replacing the motorized station boat with a manually propelled dory and a peapod. However, this did not happen. Resources were found to replace the piers and keep the station's motorized boat with its hauling engine. (Courtesy of the US Coast Guard Historian's Office.)

The peapod was favored by light stations in the northeast between 1840 and 1960. Originally built in Maine for offshore lobstering and fishing, it was heavily, very seaworthy, and easily handled by one rower. Peapods were constructed by skilled craftsmen. The dory was a simpler design, lighter in weight, less expensive to construct, and less forgiving in rough seas. Each had its own benefits. (Authors' collection.)

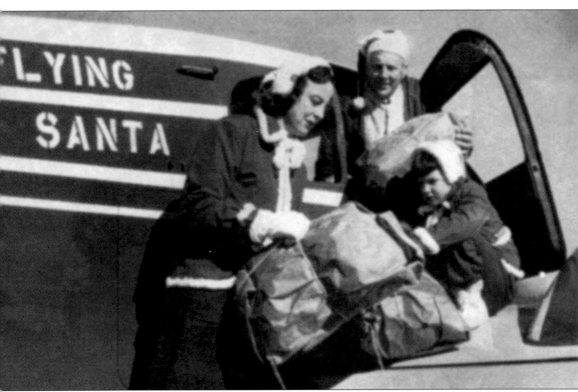

Capt. William Wincapaw, the first Flying Santa, had significantly increased the number of lighthouse Christmas gift deliveries since he began in 1929 and sought assistance. In 1936, Edward Rowe Snow was invited to be the Flying Santa for the Massachusetts flights. Weeks of preparation went into acquiring and bundling gifts. They were wrapped in brown paper, and twine was tied tightly around the packages to ensure they survived hitting the ground when dropped from the plane. Bundles containing such items as candy, coffee, tea, gum, cigarettes, magazines, books, and toys were prepared at Snow's home in Marshfield, Massachusetts, with helping hands from family and friends. This 1957 photograph shows Edward Rowe Snow in his Santa suit loading the airplane. Snow is assisted by his wife, Anna-Myrle Snow, and daughter Dorothy Snow. Today, Friends of Flying Santa Inc., a nonprofit educational organization, continues this New England tradition, delivering gifts mostly to Coast Guard stations and a few lighthouses such as Boston Light. (Authors' collection.)

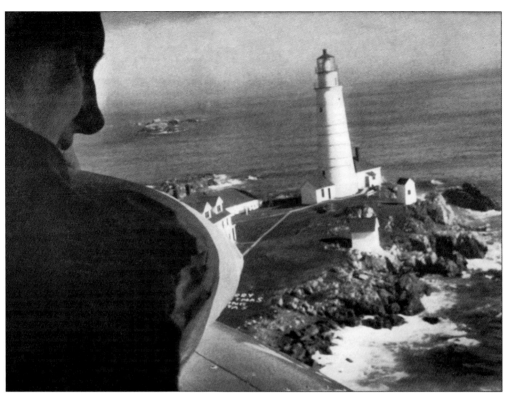

Flying Santa is preparing to drop a gift package from the plane onto Little Brewster Island in 1957. The pilot adjusts his speed and altitude, coming in slow and low to increase the probability of the package landing intact on the beach. This was Edward Rowe Snow's 20th year flying the Santa missions—20 years to perfect the drop. (Authors' collection.)

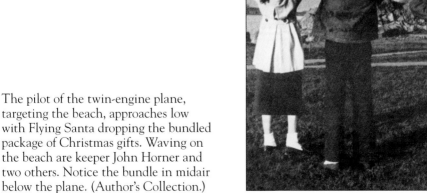

The pilot of the twin-engine plane, targeting the beach, approaches low with Flying Santa dropping the bundled package of Christmas gifts. Waving on the beach are keeper John Horner and two others. Notice the bundle in midair below the plane. (Author's Collection.)

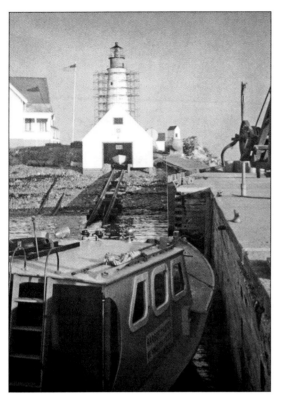

On November 15, 1958, a christening was held for keeper Horner's two children. The Weymouth Harbor Master police boat in the foreground transported the minister of Pilgrim Congregational Church in North Weymouth, Massachusetts, and guests to Boston Light. The baptism took place in the living room of the keeper's house. Three-month-old Marcia Jean Horner was held by her mother, Emma "Lilly" Horner. Four-year-old Leslie Jean Horner stood by her farther, keeper John Horner. Rev. Donald Ward performed the baptism. Others who attended from the mainland were Nancy Ward, the reverend's wife; Frank F. Bartlett; Edward Rowe Snow; and harbormaster Cecil Evens. At this time, the lighthouse was being repaired, and scaffolding is visible around it. Below, Reverend Ward is standing by the tower. (Both, courtesy of Pilgrim Congregational Church.)

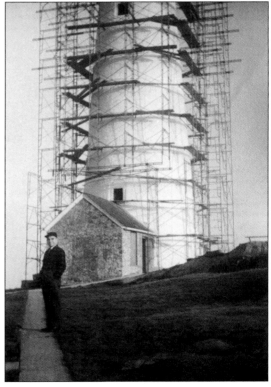

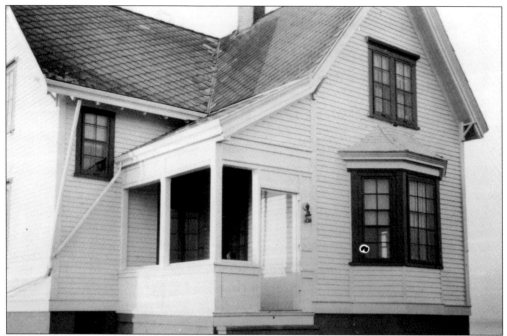

Winter and spring storms did significant damage to the keeper's house, as illustrated by these photographs taken on April 23, 1959. Above, the bare roof is showing where many asbestos shingles have been blown off. Below is a demonstration of the power that tides and surf had on the house, with a knocked-out window in the cellar and many of the shingles swept away. Renovations in the coming years would replace the wood-frame outer cellar wall with concrete blocks and eliminate the large windows. The house's front-porch windows and door that were installed 1938 have been removed. (Both, courtesy of the US Coast Guard.)

The two-family house built in 1859 was in disrepair as seen in this April 23, 1959, photograph. With plumbing not yet installed, the kitchen sink's hand pump remained in use. The rat hole visible behind the pump was just one of many in the house. Come 1960, families would no longer reside on the island, and the duplex was removed. (Courtesy of the US Coast Guard.)

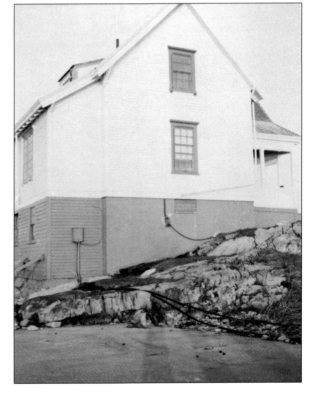

In 1959, keeper James B. Collins replaced John Horner as the officer in charge of Boston Light. In this transition, renovations were made to alter the single-family dwelling to accommodate four active-duty men. One of the projects was updating the kitchen with new cabinets, a sink, and a refrigerator. (Courtesy of the US Coast Guard.)

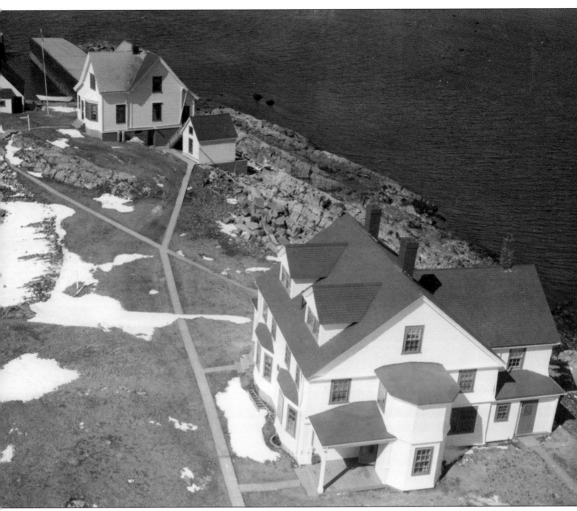

Taken in March 1959, this aerial photograph shows remnants of snow on the ground. The boathouse is adjacent to the piers in the background, the principal keeper's dwelling with barn is to the right, and the assistant keepers' duplex is in the foreground. The flagpole has been moved from the middle of the island to its present location on the front lawn between the boathouse and the keeper's house. Soon, the Coast Guard's modernization initiative would require Boston Light to become a "stag" or bachelor station. Only the principal keeper and assistant keepers would remain on the island, residing in the 1884 keeper's house. Wives and children were in the process of being relocated to the mainland in preparation for the duplex dwelling to be removed. The keeper's house barn would also be removed. Keeper John Horner's family would be the last to reside on Little Brewster Island. (Courtesy of James Claflin.)

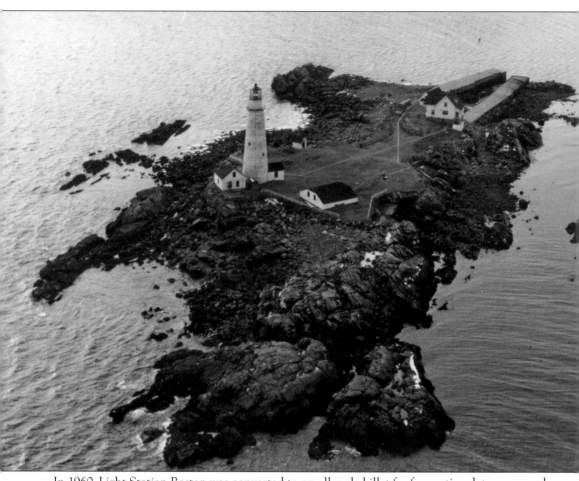

In 1960, Light Station Boston was converted to an all-male billet for four active-duty personnel, residing in the 1884 single-family house. There was no need for the 1859 duplex. Burning the structure was deemed the best way to remove it. The Coast Guard posted a statement in the *Local Notice to Mariners* advising the maritime community of the intentional burning of the duplex on Monday, April 25, 1960. In preparation for the burn, the keeper's house and cistern building were hosed down to protect them from the heat of the flames. Holes were made in the roof and walls of the duplex. The fire was strategically set in the attic to ensure the roof collapsed inward. The draft drawn from the holes in the walls collapsed them inward, resulting in the structure progressively burning downward, caving into the cellar. The mission was accomplished. The profile of the island significantly changed, as seen in this 1961 aerial photograph. Where the huge duplex house once stood is now open space. (Courtesy of the Coast Guard.)

Four

1960 AND BEYOND

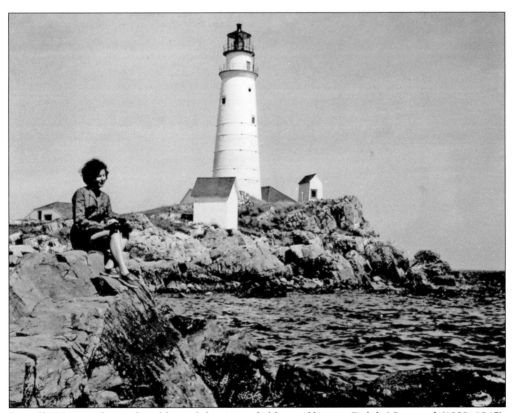

Priscilla Norwood was the oldest of the nine children of keeper Ralph Norwood (1929–1945). When he was reassigned to Ram Island Light in Maine, Priscilla Norwood remained in the area, marrying and raising a family. She visited Boston Light whenever the opportunity was provided. This photograph was taken on such a visit in 1960 at age 38. (Courtesy of Jeremy D'Entremont from the Edward Rowe Snow Collection.)

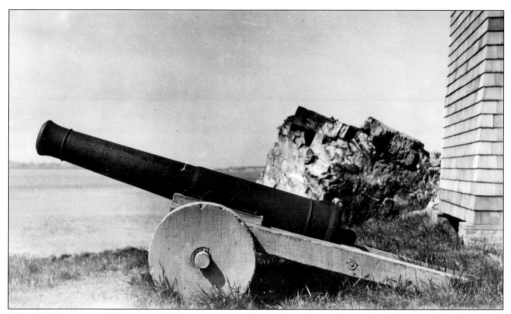

The 1719 fog signal has gained distinction as being the Coast Guard's oldest artifact. In 1963, it was deemed appropriate to move the cannon to the Coast Guard Academy in New London, Connecticut, for its artifact collection. The transfer was made discretely, with only those involved with the project having knowledge of its removal from the island. The above photograph shows the cannon displayed on the island around 1950. Below, it is displayed on the academy grounds with a new carriage sitting on a concrete foundation. It remained in this location until 1993, when the decision was made to return the cannon to Boston Light, where its story could be told in context of its original use as a fog signal. (Both, courtesy of the US Coast Guard Historian's Office.)

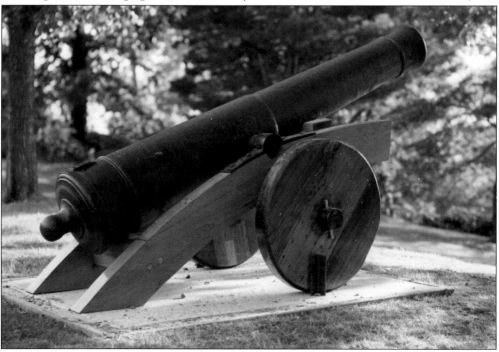

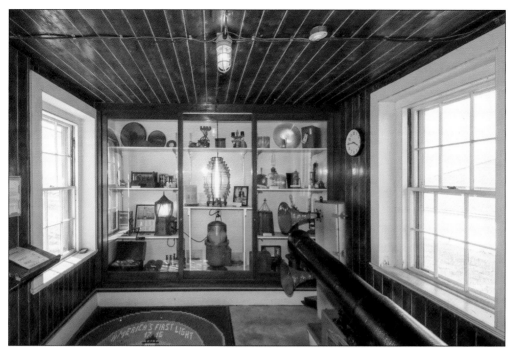

During the Coast Guard lighthouse modernization effort in the 1960s, obsolete aids to navigation and lighthouse apparatus were disposed of. Chief Warrant Officer Kenneth Black, commander of Coast Guard Group Boston, realized that some of these objects should be preserved as artifacts. A display case was built in the vestibule at the entrance to the base of the tower by Black and keeper William Mikelonis. (Courtesy of Brian Tague.)

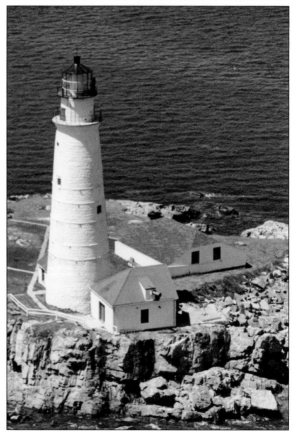

This aerial photograph, taken in 1963, shows that the exterior entrance door to the fog signal building has been removed. A fog signal horn protrudes from the roof dormer. A wooden fence has been set along the ledge by the front of the building to prevent inadvertent and dangerous falls. (Courtesy of the US Coast Guard Historian's Office.)

In 1964, the US Department of Interior designated Boston Light a National Historic Landmark within the National Park Service to encourage preservation of it as a historical and archeological site. Above, a bronze plaque with a certificate was presented at the First Coast Guard District headquarters in Boston on July 27, 1964. From left to right are Rear Adm. James A. Alger; Edwin W. Small of the Department of Interior; and Lt. Comdr. R.H. Wood, chief of the First District Aids to Navigation Branch. On this same day, the plaque was brought to Boston Light and affixed to the exterior of the entrance to the tower. Below are, from left to right, Rear Admiral Alger; Osborne Earle Hallett, former Boston Light US Lighthouse Service assistant light keeper (1937–1944); and keeper William F. Mikelonis (1962–1967), officer in charge. (Both, courtesy of US Coast Guard Historian's Office.)

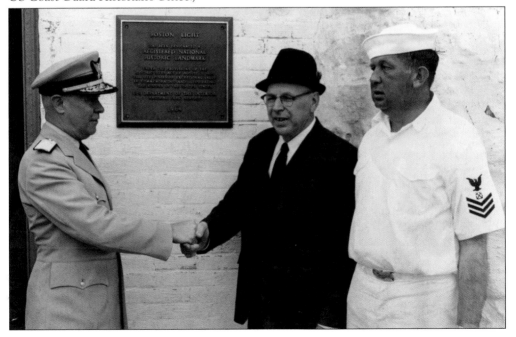

This c. 1960 photograph shows the fog signal building with it siren horn protruding from its dormer. In 1962, this device was replaced with a two-horned diaphragm signal producing a deep "beeee-yooooo" sound. Fuel oil storage tanks are visible between this building and the tower. (Courtesy of the US Coast Guard Historian's Office.)

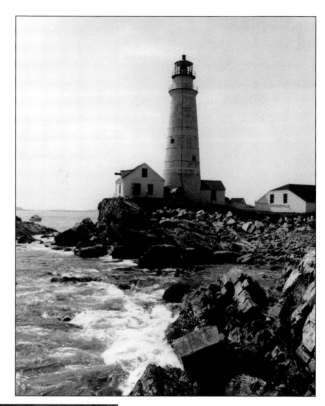

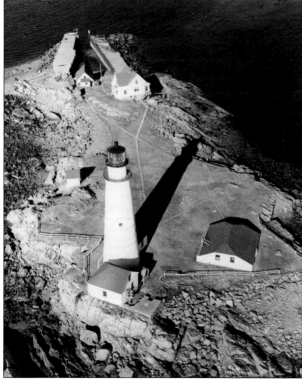

A bold shadow is cast by the tower in this 1974 aerial photograph. In the background, the pier on the left appears to be intact, as is the boat railway leading into the boathouse. However, the pier on the right has sustained storm damage from winter nor'easters. (Courtesy of the US Coast Guard Historian's Office.)

Above is a candid 1974 photograph of an unidentified assistant keeper reading a paperback novel on the living room couch of the keeper's house. The Coast Guard had recently transitioned from a khaki-colored work uniform to dark blue, as seen here. Typical of household fashion in this era, there is dark veneer paneling on the walls, a wooden bifold closet door with plastic stained-glass windows, and wall-to-wall carpeting. The coffee table was handcrafted by the Coast Guardsmen residing on the island, and it remains in use today. Below is the living room after a 1996 restoration project adhering to historic preservation standards. The paneling and carpet are gone. (Above, courtesy of US Coast Guard Historian's Office; below, authors' collection.)

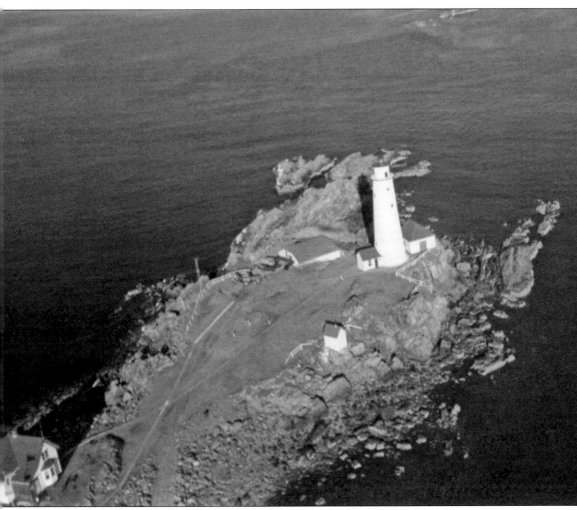

The landscape of the island around 1983 looked very different with the duplex house gone. A 4,000-gallon underground diesel fuel storage tank with a container wall was installed in the cellar, replacing the numerous aboveground tanks. Although an underwater electric power line had been laid from the mainland in the 1960s, the island also had a backup generator. Fuel was needed for the generator as well as for the keeper's house furnace. Underground fuel lines were laid from the underground tank to smaller tanks in the fog signal building and the cellar of the keeper's house. An automatic underground transfer system distributed fuel to smaller tanks as needed. An erosion protection project was also underway. A backhoe is visible placing gabions (rocks in wired cages) along the north side of the island by the cistern building. (Authors' collection.)

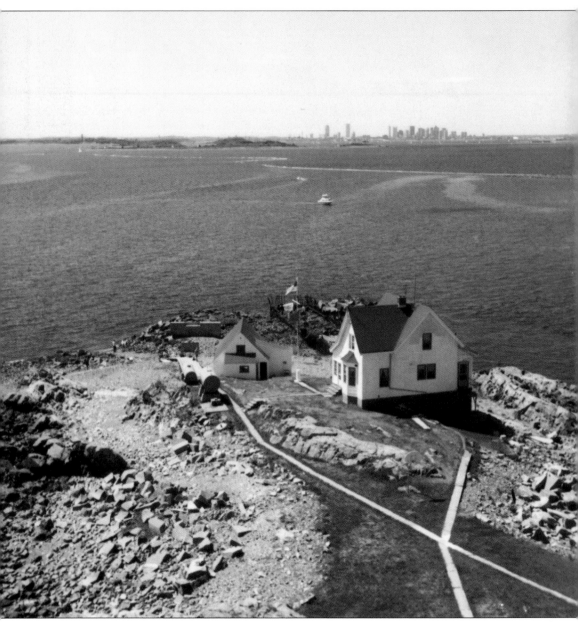

This view of the west end of the island taken in 1983 shows the continuing deterioration of the north pier and the ongoing reconstruction of the south pier. The February blizzard of 1978 destroyed it, and it took five years to remove the remains and design and build a replacement. In the meantime, access to the island for active-duty personnel was extraordinarily challenging, with the station boat having to land on the unprotected stony beach. The pier would be completed in 1985. Another erosion protection project in 1983 required earth-moving equipment on the island. The beach visible to the left gives evidence of a rudimentary road cleared for vehicles to access the island. In 1982–1983, a small room was constructed on the north-side boathouse to accommodate new electric cable switches and a fuel pump system. The fuel deliveries at the west end of the island needed to be transferred to the underground storage tank via the pump. Today, the room is the engineering and tool locker. (Courtesy of the US Coast Guard.)

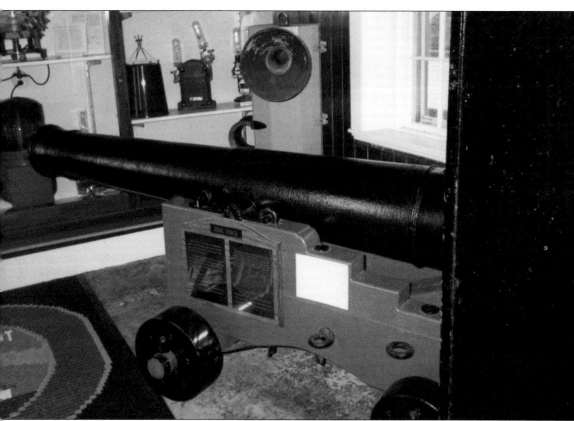

On December 21, 1992, the 1719 fog signal cannon was delivered to the USS *Constitution* Refurbishing Repair Facility in Charlestown, Massachusetts, for restoration and construction of a new carriage. On May 17, 1993, the Coast Guard transported the cannon from Charlestown to Boston Light via helicopter. It was placed inside the small museum room at the base of the tower to be protected from the weather. Today, it remains on display in the museum. (Authors' collection.)

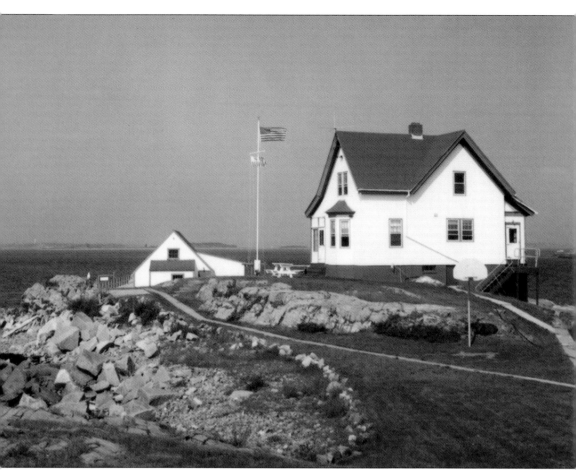

Boston Light was slated to be automated and unmanned in 1989. Boatswain's Mate 1st Class Dennis Dever, the officer in charge, was to be the last keeper in its 273 years of service. Instead, on November 18, 1989, congressional legislation declared that Boston Light, as the oldest light station in the nation, was to remain permanently manned. It stipulated the station was to maintain a Coast Guard presence and to develop and implement a strategic plan that would allow for public access. The plan continues to be maintained by the Coast Guard and the Boston Harbor Island National and State Park Partnership. This photograph shows the keeper's house to the right and the boathouse in the background. The outstretched flags flying from the flagpole indicate 20–25 knot winds from the southwest, typical for Little Brewster Island. Notice the basketball hoop in the foreground. (Courtesy of the US Coast Guard.)

The Coast Guard funded a renovation project in 1996 to restore the interior of the 1884 keeper's house to historic preservation standards. Both of these photographs dated 1996 are of the stairwell in the keeper's house. One was taken during the restoration work and the other after it was completed. The walls were gutted to the lathing, exposing the quality workmanship of the construction. The graceful curvature of the stairwell is reminiscent of stairs in a lighthouse tower. New wallboard was installed and painted a light beige. Many years of dark wood stain were removed from the steps and banister. Clear polyurethane was applied, allowing for the natural color of the wood to remain exposed. The stair risers were painted white. (Both, authors' collection.)

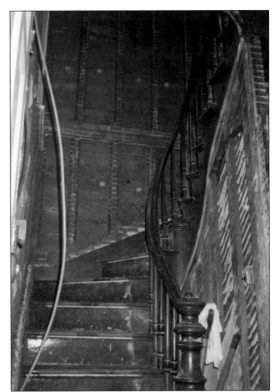

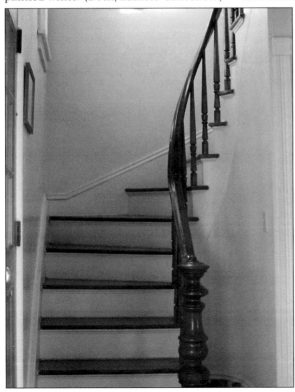

During the Lighthouse Service era, the room depicted in these photographs was referred to as the "day room." This was a multipurpose space for children to play board games, do their homework, make crafts, and the like, as well as a dining room. In 1960, the room became office space when the house was repurposed into quarters for activity-duty Coast Guard personnel. The dark paneling, false ceilings with florescent lighting, and wall-to-wall carpeting installed in 1970 were removed during the 1996 restoration project. The hardwood floors were refurbished and the ceiling restored to its original state. (Both, authors' collection.)

In the 1990s, the station boat was a 17-foot rigid inflatable boat with a fiberglass bottom and inflatable sides. A hoist at the end of the pier was used to lower and haul the boat. It was stowed on a trailer that was manually pushed down the 100-foot pier. When not in use, it was stored in the boathouse. There were three active-duty personnel assigned to the station, rotating two weeks on the island and one week off. Two would have the duty while the third was on the mainland. Transportation to the island was via the 17-foot boat. Launching and hauling the boat occurred all year, including the wintertime, when it was pushed down the icy pier on the trailer. (Both, authors' collection.)

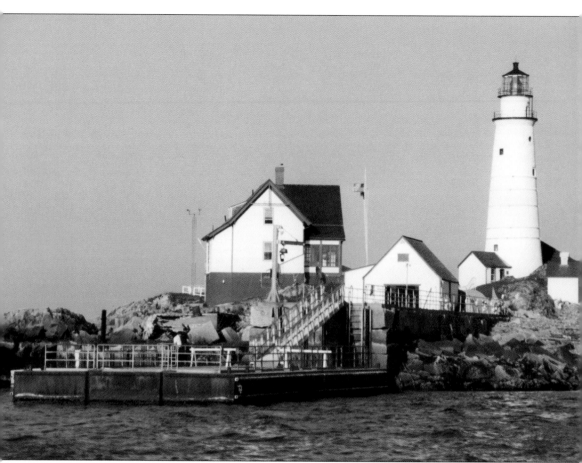

The Boston Harbor Islands National and State Park was established in 1996 with Little Brewster Island one of the 34 islands and peninsulas comprising the park. The Coast Guard and Park Service became partners ensuring public access to the island as mandated by law, with the tours first offered in July 1999. The island, only accessible by a concrete pier, needed to acquire a seasonal dock for the tours. A 40-by-80-foot barge borrowed from the Massachusetts Port Authority was used as a temporary dock. Access from the barge to the pier was via a 50-foot gangway. Boston Harbor's nine-foot average tidal cycles determine the amount of incline of the gangway. At low tide, it is steep, as seen here. There is a 16-week window of opportunity to offer tours during the summer season. The outer harbor sea conditions quickly deteriorate in fall, winter, and spring and would damage the barge if it were not removed. (Authors' collection.)

The first National Park Service tour to Boston Light was on July 27, 1999. Transportation was via a leased boat from the University of Massachusetts Marine Division. It was a refurbished 1940s wooden-hull fishing boat named the *Hurricane.* Two park rangers accompanied 32 visitors. On the island to meet and greet the boat were two on-duty Boston Light Coast Guardsmen and two Coast Guard Auxiliary volunteers. The boathouse was transformed into a rustic visitor center. During the tour, visitors were provided historical information about the light station and invited to meander the island. They also had the opportunity to climb the 76 spiral stairs and two ladders to the top of the lighthouse tower, taking in the views from the lantern room. (Both, authors' collection.)

Friends of Boston Harbor Islands is a nonprofit organization of volunteers established in 1979. They had offered tours to Boston Light since the 1980s, precariously mooring at the end of the pier. In September 1999, they were able to offer their sponsored tour with the convenience of the seasonal dock. They leased the vessel *Martha Washington*. (Authors' collection.)

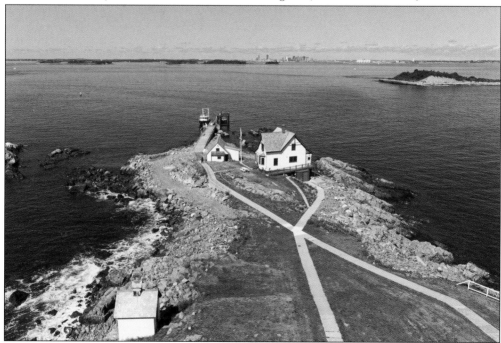

During scheduled tour days, visitors have the privilege of climbing the lighthouse. On clear days, there are spectacular views. The inner harbor islands are visible to the west, with the city of Boston on the horizon. To the north are Graves Light and Cape Anne in Gloucester. The Atlantic Ocean is to the east. South views are of the mainland a mile away. (Courtesy of Brian Tague.)

On September 17, 2003, a Coast Guard ceremony was held at Little Brewster Island announcing Sally Snowman as the appointed civilian keeper of Boston Light. From left to right are Rear Adm. Vivien Crae, keeper Snowman, piper James Toal, and Capt. Daniel May. The active-duty Coast Guard billets were reassigned. Snowman is the 70th keeper of Boston Light and the first female. A Coast Guard Auxiliary volunteer since 1976, she was instrumental in establishing the Boston Light Augmentation Program for recruiting, training, and scheduling volunteers prior to her appointment as keeper. Congressional legislation requiring a Coast Guard presence at Light Station Boston has been met with keeper Snowman and a cadre of Auxiliary volunteer assistant keepers manning the island. Below is the keeper tending to the flower garden. (Both, authors' collection.)

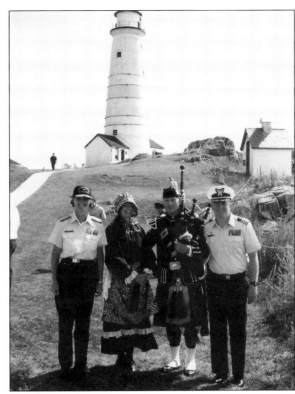

Machinery Technician 2nd Class Ben O'Brien was the last activity-duty Coast Guardsman billeted at Boston Light, with his last day June 16, 2004. It was also the day he reenlisted for another four years, being assigned to another billet. A brief ceremony took place on the first deck at the top of the lighthouse tower. The above photograph shows O'Brien (right) signing the reenlistment papers under the observation of Chief Warrant Officer Kristopher Stober. Before departing from his four years as an assistant keeper at Boston Light, he performed the ancient tradition of engraving his name in stone, pictured below. (Both, authors' collection.)

The black Labrador is the Coast Guard's mascot, adopted from the Lifesaving Service when it was absorbed into the Coast Guard. There are numerous stories about dogs that served at lighthouses, including Boston Light. The last official Coast Guard lighthouse dog was Sammy. Arriving at Boston Light in July 1997, he was seven years old, having served at two previous mainland stations. He enjoyed exploring the island, including the lighthouse, accompanying Boatswain's Mate 1st Class Scott Stanton up to the 76th step. On a dark and stormy night, Stanton and Sammy went to check the tower. More than halfway up, Sammy fell down 50 feet between the interior wall and the iron staircase. He survived, recovering from a concussion and bruises. For the seven years Sammy was on the island, he was a wonderful lighthouse companion. On October 4, 2004, at the age of 14, Sammy died of old age. He is buried on the northeast corner of the island, with his grave marked with a headstone. (Authors' collection.)

Since the late 1800s, there have been efforts to protect the island from erosion. In 2005, the Coast Guard funded a million-dollar erosion project. It included repair of existing gabions and the addition of more. Gabions protect the shoreline from being washed away by absorbing and dispersing the shock of powerful waves. (Authors' collection.)

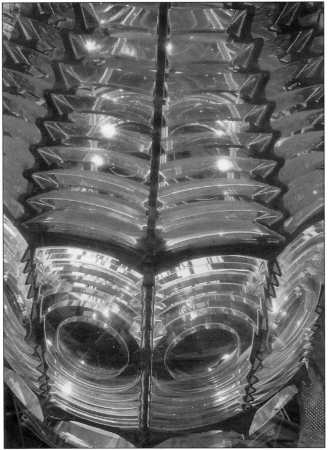

The second-order Fresnel lens installed in 1859 was refurbished by the Coast Guard in 2006–2007. The base of the lens was leveled. The worn chariot wheels that rotate the lens were replaced. Decaying litharge, a putty-like substance that secures the 336 prisms in the brass frame, was restored. Chipped and cracked prisms were mended where possible. (Authors' collection.)

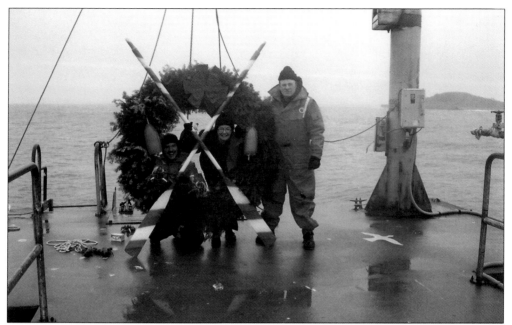

In December 2007, preparation for Flying Santa's annual visit was in progress. A local lobsterman, Steven Holland, made his annual wreath delivery to Boston Light for hanging at the top of the tower. The Coast Guard Auxiliary assistant keepers who had successfully hoisted the wreath and lobsters from the boat are, from left to right, James Thomson, Colleen Kloster, and James Healy. Taken to the tower, the wreath was hoisted to the first deck and secured to the ladder leading to the upper gallery. Holiday lights were placed on the wreath as well as the handrail. Other preparations included baking cookies for Santa and his helpers. Below, the helicopter pilot makes an approach for landing on the island, transporting Flying Santa and his bag of gifts. (Both, authors' collection.)

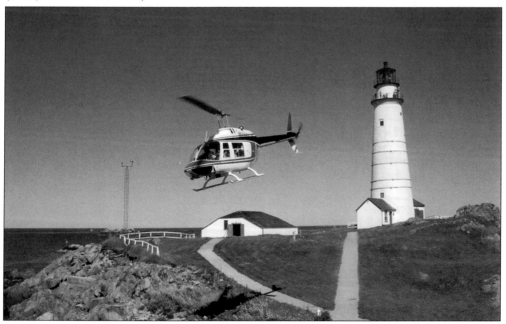

Flying Santa, also known as Chief Warrant Officer David Waldrip, poses with keeper Sally Snowman as she accepts the gift. The package contained coffee, tea, candy, a *Farmer's Almanac*, and more. The photographer in the foreground is Brian Tague, president of Friends of Flying Santa Inc., the nonprofit organization that maintains the tradition. (Authors' collection.)

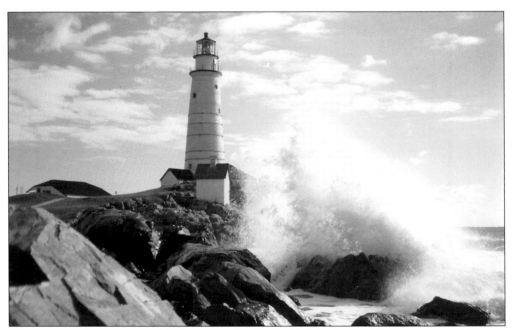

Winter seas at the entrance of the harbor can build quickly. The force of the wave pictured here on a December day could be felt while sitting in the keeper's house. The roar of the seas pounding on the rocks prevented the words of the assistant keepers from being heard. (Authors' collection.)

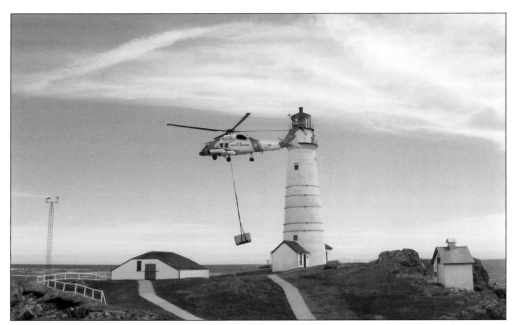

The keeper's house restoration project in 1996 did not include window replacements. That project was funded separately by the Coast Guard in the winter of 2006, refurbishing the 1950s-vintage windows. The easiest access to the island for removing the windows, refurbishing them, and returning them was via helicopter. Exterior storm windows were left in place with plastic mounted on the interior as a means for the house to retain its heat. The photograph above shows a cargo box in a sling suspended from a Coast Guard helicopter. The staging location for the transfer on the mainland was a mile away in Hull. Below, the restored windows are installed. (Both, authors' collection.)

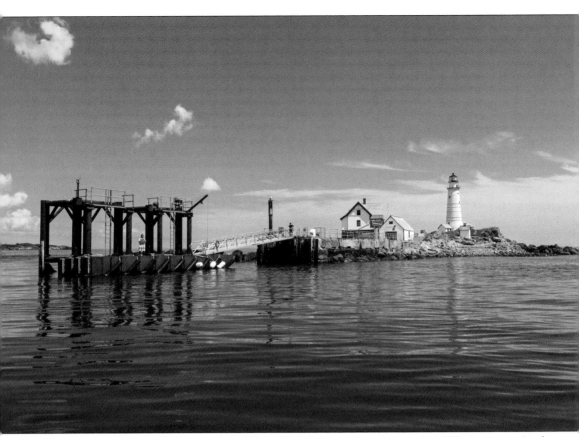

Boston Harbor Islands National and State Park began offering tours in 1999. Access to Little Brewster Island was via a barge loaned from the Massachusetts Port Authority. During the summer season, it functioned as a floating dock. This was a temporary arrangement until an appropriate docking facility could be designed and constructed. Although the light station and island are owned by the Coast Guard, the National Park Service funded the $1.8-million project to provide safe access for sponsored tours. Due to the harsh environment, a massive permanent piling system was constructed, as seen here. Public access was unavailable during the summer of 2009 due to construction. Tours resumed in 2010. A 10-by-50-foot dock is secured to it during the 16-week tour season. A 50-foot aluminum gangway connects the dock to the pier. To prevent the gangway from excessive movement on the dock in choppy seas and ocean swells, it is hoisted via an electric motor from the first piling set and remains suspended when not in use. (Courtesy of Brian Tague.)

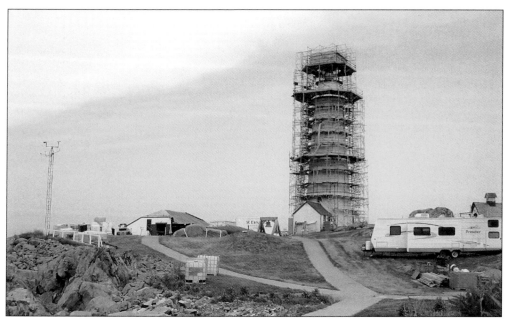

A major repair and restoration project was funded by the Coast Guard in 2014 in preparation for Boston Light's 300th anniversary in 2016. The island had become a construction site that created unsafe conditions for visitors. Park service tours were cancelled for the season. Contractors worked from May to December. Equipment and supplies were delivered to the island via barge. A temporary road was made by clearing rocks from the beach. Forklift vehicles brought by barges pushed by tugboats transported material to various locations on the island. To maximize the workday, a 36-foot camping trailer provided overnight accommodations for some of the contractors. There were also two 24-foot trailers containing contractor tools and office space. Multiple buildings were worked on simultaneously, with roofs reshingled, exteriors painted, and the lighthouse tower refurbished. (Both, authors' collection.)

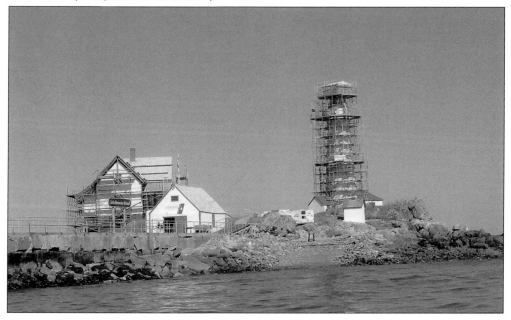

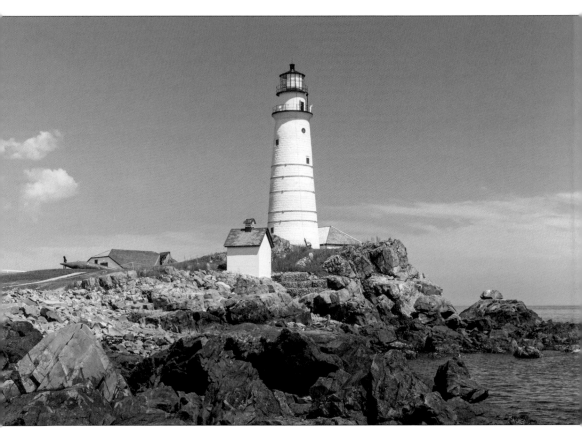

Contractors returned to Boston Light in the spring of 2015 to finish masonry repairs to a portion of the tower that provided evidence of the original 1716 foundation. The granite showed stress that could have only been caused by extreme heat, such as exposure to an exploding keg of gun powder used by the British to blow up the structure when they evacuated Boston in 1776. There was a clear differentiation between the lower 1716 and newer 1783 stonework above. Re-pointing the tower's exterior in 2014 proved far more extensive than had been planned: the depth of mortar repair between the stones was time-consuming, placing the project behind schedule. Once completed, stucco was applied. While the masonry work was in process, the five iron window frames in the tower, the lantern room window frames, and the tower's copper roof were refurbished, and the lantern room windows were replaced. This photograph shows the refurbished tower. The oil house in the foreground received repairs to its slate roof, and the brick exterior was painted. (Courtesy of Brian Tague.)

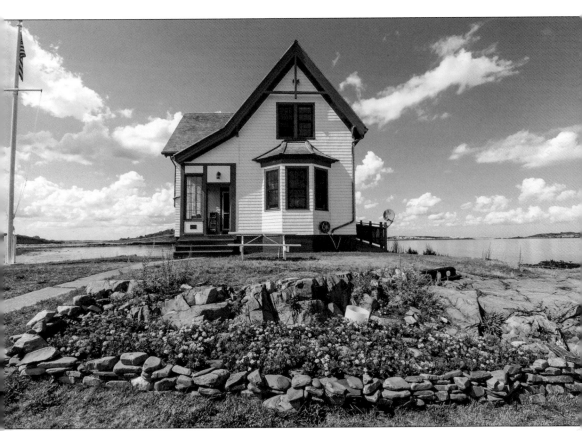

The exterior of the 1884 keeper's house was refurbished to historic preservation specifications in 2014–2015. The classic red asbestos shingles that were used for roofing materials at lighthouses and lifesaving stations in the early 20th century are now deemed health hazards. In 1996, Boston Light's red asbestos shingles were replaced with red cedar shingles; these were replaced with high-quality Alaskan yellow cedar shingles during the 2014 restoration project. Once completed, damage caused to the interior of the house from the previous leaking roof was repaired. All new hurricane-grade windows were installed, including in the cellar and on the porch. The vintage look of the house was returned, with the exterior aluminum storm windows removed. The house was painted white with green trim and red foundation, traditional colors of this era. The satellite dish on the right, affixed to the handrail of the walkway leading to the back door, and the outside light over the porch door place this photograph in the current century. (Courtesy of Brian Tague.)

The photograph above shows the 1876 fog signal building with its exterior refurbished in 2014, painted the traditional colors of white with green trim and red foundation. The fog signal double horn set is visible in both photographs. The sensing device that automatically activated the horn when visibility dropped below a quarter-mile is visible in the window to the right. However, in December 2014, the fog signal device was solarized, no longer requiring the use of the sensor. Mariners now activate the signal via VHF-FM marine radio channel 81A. Clicking the microphone button five times triggers the horn to sound. It shuts itself off after 45 minutes. (Both, courtesy of Brian Tague.)

The classical Fresnel lens mechanism, installed in 1859, is old technology adapted to the 21st century; consequently, it sometimes malfunctions. When this occurs, a backup system automatically activates. There are two LED lights affixed to the handrail of the first deck set 180 degrees apart, ensuring a 360-degree visibility to mariners. Their energy source is a very small, discretely placed solar panel device located low to the ground on the southeast corner of the island, pictured below. The energy acquired from the solar panel is stored in two batteries that provide electricity to the fog signal horn and the two backup lights. (Both, authors collection.)

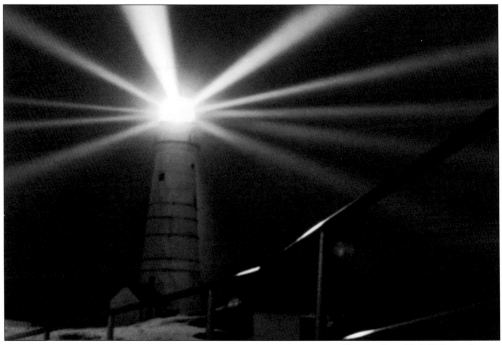

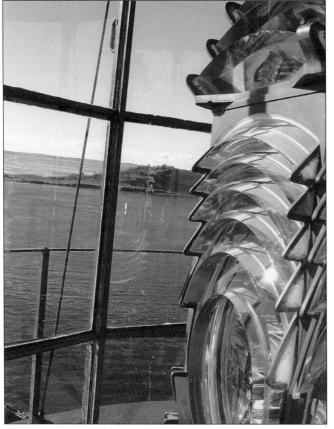

September 14, 2016, marks Light Station Boston's 300th anniversary. The number of technological, structural, personnel, and management transitions that have occurred during these three centuries have had inconsistent and sometimes scanty documentation. Contained in this book are snapshots representing 109,575 days of Little Brewster Island's history. Today, by night, Boston Light continues lighting the way into Nantasket Roads as it has done since September 14, 1716. During daylight hours, it is a day mark recognizable by its white cylindrical tower, its five aluminum bands, and two decks at the top, one at the lantern room level and another below. The 1859 Fresnel lens keeps its watchful eye on the horizon. (Both, authors' collection.)

The Coast Guard's 300th Anniversary Planning Group collaboratively developed the concept for a logo. Petty Officer Samantha Stone created a first rendition of the graphic. The lighthouse station, with beams emanating from the lantern room, lights the way into the harbor. At left is the USS *Constitution*, representing naval protection for the harbor. A contemporary ship to the right represents flourishing commerce. In the background is the prosperous city of Boston, continuing as an international seaport. Boston Light is not the oldest standing lighthouse in the country; that designation belongs to Sandy Hook Lighthouse (1764) in New Jersey, having sustained itself through the Revolutionary War. However, Boston Light is the first established light station in America and is legislated to remain the last manned Coast Guard light station in the country. It is with this designation that Boston Light's 300th anniversary has come into fruition. Lynn Waller, of neighboring Graves Light, has refined Stone's graphic rendition as seen here. It has been adopted as the official 300th anniversary logo. (Courtesy of the US Coast Guard.)

BIBLIOGRAPHY

Crosby, Irving B. *Boston Through the Ages*. Boston, MA: Marshall Jones Company, 1928.

Emerson, Willie M. *First Light: Reminiscences of* Storm Child *and Growing Up on a Lighthouse*. East Boothbay, ME: Post Scripts, 1986.

Putnam, George R. *Lighthouse and Lightships of the United States*. Boston, MA: Hough Mifflin Company, 1933.

Smith Jr., Fitz-Henry. *The Story of Boston Light*. Boston, MA: Privately published, 1911.

Snow, Edward Rowe. *The Islands of Boston Harbor: Their History and Romance 1626–1935*. 2nd ed. Andover, MA: The Andover Press, 1936.

———. *Famous Lighthouses of New England*. Boston, MA: Dodd, Mead & Company, 1971.

Snowman, Sally, and James Thomson. *Boston Light: A Historical Perspective*. Plymouth, MA: Snowman Learning Center, 1999.

INDEX

DISCOVER THOUSANDS OF LOCAL HISTORY BOOKS
FEATURING MILLIONS OF VINTAGE IMAGES

Arcadia Publishing, the leading local history publisher in the United States, is committed to making history accessible and meaningful through publishing books that celebrate and preserve the heritage of America's people and places.

Find more books like this at
www.arcadiapublishing.com

Search for your hometown history, your old stomping grounds, and even your favorite sports team.

Consistent with our mission to preserve history on a local level, this book was printed in South Carolina on American-made paper and manufactured entirely in the United States. Products carrying the accredited Forest Stewardship Council (FSC) label are printed on 100 percent FSC-certified paper.

MADE IN THE
USA